THE BOOK OF BETH

Aperture Foundation, Inc., publishes a periodical,
books, and portfolios of fine photography to
communicate with serious photographers and creative
people everywhere. A complete catalog is available
upon request. Address: 20 East 23 Street, New York,
New York 10010.
All rights reserved under International and Pan —
American Copyright Conventions.
Also published by Norstedts, Sweden, Oktober,
Norway and Tiderne Skifter, Denmark.
Designed by Tina Enghoff
Translated from the Danish by Ellen Bick Meier.
Printed by Bildtryck AB, Sweden

Library of Congress Card Catalogue No.: 88-082655
ISBN: 0-89381-370-2

THE BOOK OF BETH

KENT KLICH

CONTRIBUTIONS
FROM

CORNELL CAPA
BENGT BÖRJESON
BETH R.
SVEND HEINILD

TRANSLATION
BY

ELLEN BICK MEIER

APERTURE

As a courtesy, the names of certain individuals in the Book of Beth have been changed.

I want to thank my friends:

Beth, Børge, Poul, and Alfred for opening your doors and letting me enter your lives.
Tina Enghoff, who lived the life of this book with me and provided ideas on the structure and content.
Svend Heinild for helpful advice and for the journals.
Fred Ritchin, without your support this book could not have been published in the United States.
Maria Almén, Pamsi Enghoff, Sharon Gresh, Daniel Kazimierski, Michael Mc Ginn, Gary Metz, Ralph Nykvist, Anders Petersen, David Spear, Richard Vincent, Peggy Weiss, Göran and Tinna Widerberg and Via Wynroth for your support and encouragement throughout.
Konrad Ahlgren and David Skoog for printing the pictures.

Kent Klich

FOREWORD

It is like climbing mountains: when one reaches a peak, another one becomes visible. Gene Richard's book Exploding Into Life, the story of his companion Dorothea Lynch, a victim of cancer was such a high. A close relationship, an emotional, high intensity relationship heading towards a tragic end. The photographer, the patient, the loved one, who writes so well. The photographer with the ever-present camera, recording the most painful and intimate moments.

Now comes The Book of Beth by Kent Klich. Beth is a prostitute, an addict, painstakingly recorded through her horrid life experiences: drugs, sex, degradation. Klich is the stranger, the photographer looking on. You will turn the pages and see it all for yourself. Kent Klich dug in deep and learned from family albums, police records, doctor's case records. A whole life unfolds and becomes a deeply touching social document, a descent into death and oblivion.

It is a highly disturbing book on many levels. It raises questions about Beth's right to privacy, and the assumed right of the ever-present camera, held not by a lover, but a recording voyeur.

Great photographs, social revelations, important contributions to the understanding of our times in the eighties, visual history, social commentary, a learning experience of great value – yes, the book has it all. I am exhausted by the experience. I am drained. Where is the next peak? Who will scale it? Will the patient die and the photographer survive? As for now, The Book of Beth is here. It is a deep experience, a new peak and we shall have to contemplate all its deep and complex meanings.

Cornell Capa

You have closed your window
hung curtain upon curtain
just a strip of light comes in.
You want to keep the world out
but even here in the darkness
you don't find peace.

The only thing which helps is a fix.

You're crouched
in a corner of yourself
smiling.

Spring is here.

I can't remember the first time
we met
but the smells are still around.
The smell of cigarette butts
soiled clothes and Oil of Ulay.
And your drive for freedom.

This book is for you Beth
and everyone who fights
to beat drugs
and to start living.

Kent Klich

1983

Dear Kent!
Happy happy New Year and lots of luck to all of us. With hopes for a fine friendship, which I'm sure it will be.
I am really happy that you want to see me this Saturday even though I don't really understand why.

Love from Beth

Kære Kent!

Rigtig godt Nytår
og held og lykke med på
vejen til os alle, med
håb om godt venskab
hvad jeg ikke tvivler på nok skal
gå godt. Jeg er glad, i alder se
mig på lørdag selvom jeg
ikke forstår det

Beth

ABOUT MY LIFE

How I looked forward to my sister picking me up at the train station! But she didn't show up. I was only four and on my way back from the home for children where I'd been placed. The woman from the institution had to go with me all the way to the door. I got really scared when she rang our bell, and I hid behind her. Something had to be wrong there when my sister didn't show up to meet me. My Mother opened the door a crack. "What do *you* want?"

That was exactly what she said. What great expectations I'd had!

As soon as the woman left, my Mother pulled up a chair in the kitchen, she had a girlfriend visiting. So I was supposed to just sit still while the two of them had a couple of drinks.

After a couple of minutes she said to me, "You look a total mess!" I'd let my hair grow because I'd always dreamed of having it real long. My Mother brought out a pair of scissors. She just started snipping a little here, a little there, zig-zag all over. It was 10 p.m. and the two of them acted like they were in the movies and really enjoying the show. I was so incredibly embarrassed that I just sat there and sobbed inwardly. What else could I do?

We were real poor and Dad worked around the clock: Dad delivered fuel for heating —

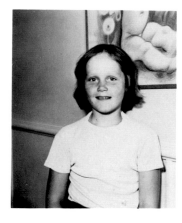

Alert, lively and daring - quick on the draw with words. A bundle of energy, tricks and ideas. Aggressive and dominating towards the other children. All over the place, especially where expected last. Starved for love - and wraps the entire staff around her finger.

MF

Excerpt from the journal.

and I hardly ever saw him. After he messed up his back, he started working at a hot dog stand. We lived on Klokke Street then. During the times when I lived at home, I would run over to his stand. And once Dad invited a bunch of my friends home on my birthday and he did all he could to make it a great party.

One Christmas I ran away from home. We

were opening the presents and my Mother looked down her nose at the presents I had made. Dad and my brother went out to find me and it took them three hours.

Once I rode in a police car up and down my block because I didn't want to tell them where I lived. And there was another incident where I had borrowed my brother's ring to take to school. The idea was to brag that I'd gotten it from a guy who was crazy about me. Later, on my way up the stairs to our apartment, I left the ring on the stairs, but some neighbours found it there and returned it. As my punishment, my Mother forced me to sit out on the stairs without a stitch of clothes on!

I was really hit like crazy. So many hangers got broken on me. My Mother beat me until I was black and blue. She went really nuts when I'd peed in bed, which I did until I was 17. Somebody had told my Mother that a piece of bread with lard and salt right before bedtime would prevent the peeing. So she woke me at 10 p.m. and told me to go and make. Even though it was impossible to just pee like that, I went to the toilet. Afterwards, I was forced to force down the lard sandwich. God, was that a pain! I couldn't stand eating it so I threw it on the floor. At midnight when she got me up again, I'd made in bed. That drove her nuts. A couple of hours later I'd done it again. Then she shoved me out into

d. 11. 12. -55

Kære lille Skat.

hermed en lille hilsen fra os alle
her hjemme. lille Beth du skriver
om ikke vi kan komme ned
og se til dig, og du kan tro
at det er ikke fordi at Far
og Mor ikke vil, men det
koster mange Penge og da det
jo snart er jul skal vi
bruge mange til julegaver.
så du skal ikke blive ked
af det hvis vi ikke kommer

Letter of December 11th, 1955.

Dear Sweetie,

Greetings from all of us at home. Little Beth, you write about whether we can come and see you, and you can be sure that it's not because Dad and Mom don't want to, but it costs a great deal of money, and since it's nearly Christmas time, we have to use a lot on Christmas presents, so don't be disappointed if we don't come, but write us some things you want so we learn what you want in the way of Christmas presents. Sweetie, we hope you're doing O.K. and like being there, because you do know that as soon as you're not O.K., you can come home, you're not forced to be there but you're there on vacation for as long as you want. If we don't come to visit before Christmas, you'll get all your presents sent there so you'll have them on Christmas Eve. Are you a big girl? Sure you are and I hear that you don't make in bed so much anymore, that's real good. Do you play with your tiny friends?

You write that you've been sick but you're surely well again so you can get up to your old tricks again.

Dad has no time these days because he's at work even though it's Sunday. Daddy's got to sell hot-dogs every day so we can make a lot of money so that you and Ida, Jørgen, Karsten and Mommy can get some swell clothes.

Remember now to send us a list of all the things you want for Christmas.

Finally, dozens of kisses and greetings to you from Ida, Jørgen, Karsten, Mommy and Daddy.

Thanks for your lovely letter, write again soon, as we long to hear from you.

One final hug for our little sweetheart.

I hope that your teacher will read this for you, because Daddy's in a rush and as I said I have to leave!

the toilet and then into the kitchen, where I was left on the table with my legs dangling down. She was totally hysterical and she made cuts on both sides of my knees. I burst into tears but was forced to keep quiet. Things would get even worse if I'd cried.

That next day, she found the lard sandwich when she was cleaning up. Remember, I'd said that I'd eaten it. So I was sent out to our little triangular toilet and was scared shit.

"Take your underpants off", she screamed at me. I didn't do it as fast as she wanted, and when she was done, you couldn't find an inch on my body which she didn't stick with pins.

Dad got wind of all this but the version he heard was glorified in her favor. And almost always when he'd just gotten home from work. So what was he supposed to do? I really loved Dad but my Mother was another case completely. She couldn't stand the sight of me. Maybe the reason for her hysterics and abuse of me was because I was the spitting image of Dad. Anyhow, the two of them decided to send me away.

My Mother was going blind and couldn't get a job. Dad killed himself trying to support four kids, first in the ghetto, then in the housing projects. And even when Dad was living by himself and sent me away, I could understand why he did it.

I'd been through so many institutions when I turned nine and started in a real grammar school. They put me in the third grade and I didn't even know the alphabet. Boy, was that embarrassing! I was the only dummy.

I remember we had to sing:
"Thanks for the meal,
thanks and you're welcome.

Great that we emptied our plates
Thanks for the meal.
And the lady that had made it sang;
Hearty appetite!"

Then I got sent to Himmelbjerggård and I really loved it there. At all these homes, I had really flipped out: I tossed knives at the grownups when I didn't understand what they did. Once I jumped from the fourth floor — onto a pile of mattresses. At last here I let myself go if I felt like it because they took good care of me. I felt good about being there and when I refused to do something, they didn't punish me. When I'd been at home, I never really got hysterical. I'd actually never done that there.

When Dad didn't get around to it, my sister Ida wrote me letters and sent me packages at the institutions. She always stood for something I could count on. My older brother and I were never close and the younger one is just a vague memory from when I was real young.

Those weekends where I was allowed to come home, I really enjoyed myself. Saturday night was spent watching t.v., but the best part was on Sunday morning: When Dad was around we ate fresh rolls and Danish pastry, drank milk and coffee for breakfast. Afterwards, we kids went into their bedroom and played on their bed and cuddled. Just when things were idyllic, everything changed.

Of course I missed having a real family. But most of my time in institutions was fine. Better than being home, anyhow. I really loved Himmelbjerggård. I was the most popular kid there. I was the kid who dreamed up practical jokes and trips. Every morning I got

a cigarette even though it was against the rules. Even better, I was allowed to smoke with one of the adults. And they gave me another half cigarette in the evening. It was really great because they weren't fanatic about following the letter of the law.

Himmelbjerggård was the last home for children they sent me to. It's also the place where I liked it so much that I was always running away from it. Just to get a thrill. Deep inside I knew I could always come back and there'd be a good dinner and a bed for me. That's what the man in charge had told the others — that I shouldn't be punished.

I stayed at Himmelbjerggård until I got confirmed. That period is the only time I'd love to relive. The place was small, very liberal — and I did get a bit spoiled!

After that I got sent to Grindsted Boarding School — and I got kicked out of there. Once on an outing, some of the girls stayed at a hotel. We stole some booze and got caught, but I was the only one who got thrown out of all of us. I guess it was because they knew I was from institutions.

Then I was sent home again. I got a job as a bellhop at Kgl. Brand, which I couldn't stand but had to stay because my Mother pressured me. I began doing other things than going to work. It was about the time when Dad and Mother got divorced. I thought it was the best thing, but Dad was miserable — which in my own exultation I didn't understand.

I was sent to another home, Klementshus in Ålborg. It was much worse than a jail and it had barbed wire on the roofs. It was incredibly religious and there were prayers and blessings before each meal. TV was turned off at 8:30 even if we were in the middle of a

good film. And we were only allowed two cigarettes a day.

After that there was an institution in Herlev. And the leader of the place in Ålborg remarked that she'd never been so happy to get rid of someone. I was real proud of that fact.

Herlev was absolutely heavenly. Nobody locked the rooms and there were ashtrays on all the tables. We were allowed out in the evenings. A lot of the girls there were lesbians and some of them picked up guys for money. That was common in 1967–68.

I went regularly to the Nyhavn section. That was the area where I heard live music for the first time — and it was a powerful experience. I went every night, started to smoke pot and eat opium, even tried shooting up once — but I was convinced that I wouldn't get hooked. About that time I started going with guys for dough. I was 17.

One Sunday afternoon, I was out for a stroll with a girlfriend and by chance we found ourselves near Halmtorvet (the red-light district, ed.). "Hey, this is the hooker street". We knew about Halmtorvet and Isted Street through some of the other girls at the Home. We felt like everybody there was staring at us. "I dare you", I said to her. It wasn't my cup of tea. My girlfriend, Lone was her name, got into the car and sat and talked and talked. "We're off for a little drive", she said to me. "Remember the money", I shouted after them.

Would you believe, it was more than a half hour before she came back — without a god-damn cent! Christ, was I pissed off! The guy turned out to be one of those young guys who tries to bullshit some young and unwary girls.

Then she picked up another guy and this time we drove with me in the back. I held on to the money. In those days, a lay in a car went down for 80 crowns a shot — and the two of us split it.

That was our scene for the next month: I was the pimp, got out of the car while they fucked. It was a breeze. Shit, it was great to get a hold of so much money. Especially for me, who didn't have to do anything for it. After a month and a half, Lone started pressuring me to work for it too. But I was scared shitless. We argued because I got my period every time it was "my turn". And I also started to think what a shame it was to fuck for 80 crowns — and only take home half of it.

When I started hooking, it was never on my own. We were always a pair in the car — and we usually drove with them to some deserted spots. We threw our clothes on the front seat and I moved to the back. Then I gave him a hand job until *it* got hard, put a

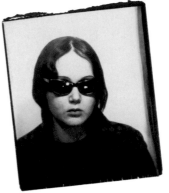

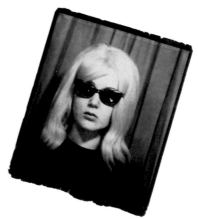

Report page 15

According to the enclosed note, policemen Olaf Sjøgreen and Finn Eriksen, have noticed lately two young girls appearing to be hookers at Halmtorvet and the area around it but each time the above tried to talk to them, they fled. On rounds last night at 11:45, the two officers noticed one of the girls in the entrance to Helgoland Street 21, and under questioning, she couldn't account for personal relations, job, and she admitted she'd fled from Højbjerggård for Girls in Herlev, and that she lived by "hooking". She was thus charged.

At that moment the other girl appeared and she admitted she had indulged in sexual intercourse with a "customer", and that it was the second time that day. She informed us that she had requested 80 crowns for this indulgence of her clients.

Both women were brought to Station 5 where the officer in charge Holger Jensen in agreement with policeman Ingemann Sørensen, at the present division attempted to have the two women removed to this division where they arrived at 1:30 a.m.

At this division a separate report is filed for each woman. With this report the name *Lisbeth Sigrid R.* given.

Police Department of Copenhagen, dept. B. Wednesday, April 11th 1966.

KØBENHAVNS POLITI

3. politiinspektorat

Afdeling B

Ugedag og dato
Onsdag den 13. april 1966
Journ. nr.
III: 931/65

Hermed: *Indberetning*

Anh. 12 /4 1966 kl. 23,45

R. R.

RAPPORT

Vedr. <u>Lisbeth Sigrid R</u>_____, f.d. 22/4 1949 i København, der er afh. i henhold til str. fl.s § 199.

Ifølge vedlagte notits har ob. 1241 Olaf Sjøgreen og pb. 2079 Finn Eriksen i den senere tid bemærket to yngre kvinder, der færdedes på udpræget trækkermaner på Halmtorvet og kvarteret der omkring, men hver gang de to ovennævnte forsøgte at kontakte dem, løb de deres vej.

Under patrulje i aftes på Halmtorvet kl. 23,45 bemærkede de to politifolk den ene af de to omtalte kvinder stående i opgangen til ejendommen Helgolandsgade 21, og da hun ved henvendelse ikke kunne gøre rede for sine personlige forhold og sine arbejdsforhold, ligesom hun indrømmede, at hun var bortgået fra pigehjemmet "Højbjerggård" i Herlev, samt at hun levede af "trækkeri", blev hun erklæret for anholdt.

Samtidig kom den anden pige til stede, og hun indrømmede, at hun netop kom fra et værelse i ejendommen, hvor hun havde plejet samleje med en "kunde", samt at det var anden gang i dag, at hun havde haft en utugtskunde.

Hun oplyste endvidere, at hun krævede sine kunder kr. 80,00 for et samleje.

Begge kvinder blev indbragt til station 5, hvor den vagthavende pa. Holger Jensen efter aftale med pa. Ingemann Sørensen, herværende afdeling, sørgede for, at de to kvinder blev indbragt her til afdelingen, hvortil de ankom kl. o1,3o.

Her i afdelingen optages særskildt rapport på hver af kvinderne.

Til rapporten her fremstår:

<u>Lisbeth Sigrid R</u>

Kbh. P. J. 3. Bl. 17 a.

rubber on him and shoved it in. If I started to gasp and scream a little, everything was over quicker. A normal day was about three Johns.

My first pickup was a cop. He couldn't get it in — it was incredibly big. Shit, I've never seen anything like it. So my girlfriend took over. So he had to pay her too, and of course there was no return on his money to me after he'd seen me with my panties off.

God, we were a couple of wild gals! If somebody tried to bargain us down in price, we'd say: "What do you think this is — bargain-day prices?"

As time went by I started to go with the John on my own. Was I tough! I had so many horrible experiences. There was the time at Islands Brygge where we were fucking on the pier. I made 200 crowns, which was a lot then. I held on and was freezing my ass off. It started to rain and thank God I'd taken my clothes out of the car. After he came, the bum threw me into the water. Then there was the time I'd gotten into the back with a John but he wouldn't pay me. He forced me to go down on him without a rubber and jerked off in my mouth. I'll never forget it.

The cops weren't after me much but once I got picked up for working at Halmtorvet. I was 18 but looked even younger. They took

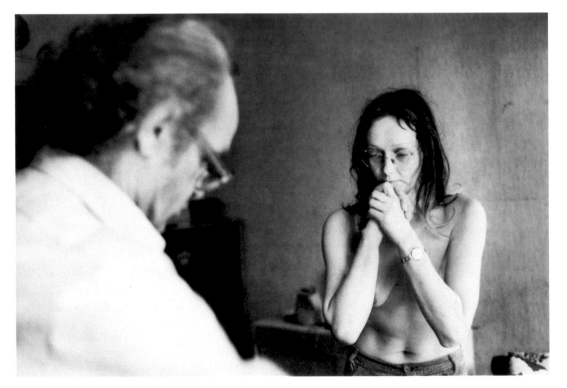

my name and address and I got two months in jail. It was in the clink that I tried to withdraw because I was scared to say that I was an addict. I was on opium and pills then. Had also started mainlining, spent my time in Nyhavn, got tossed out of the institution in Herlev and had to fend for myself. I was homeless so they put me in the hands of the Danish Society for Homeless. I told them I was an alcoholic and picked up my antabuse there every day. I had different kind of jobs then: at a hotel, at a factory for a couple of weeks, and two days some other place. There, things were so unbearable that I just took a walk in the middle of the day. The job which lasted longest was the ferry, where I worked for ten months, locally and with the Esbjerg-Newcastle, England route. But that became a drag: I just couldn't get a hold of my drugs.

I had a choice if I wanted to get the money for drugs — either pushing drugs myself or hooking. Ugh, it was disgusting! In the very beginning, it was new and exciting to some degree. But whenever I went with a John, I was high on one thing or the other. It was impossible to do it without being high. I decided to stop hooking and start pushing drugs on the street.

"The Skipper" was were I hung out in Nyhavn, but I also frequented "Vingården" and sold hashish and all kinds of stuff so I could support my opium habit. I was broke but I refused to go on welfare. I was just too proud. Nobody was going to call me a sponge. They wanted me to get down on my hands and knees and beg for help. But I couldn't manage otherwise and I went on welfare finally. It wasn't my cup of tea to pull the pharmacy fake-job or to go to Sweden

with tiny packs of felt dipped in special alcohol. And try to palm it off as drugs. Try to palm off some shit on the Swedes, who were ready to pay anything you asked for. They paid 25 crowns for a pack and all it was was this alcohol mix. It was one big con game.

I started feeling I had had enough of the whole thing. Everything I saw was rotten to the core and I started thinking about committing suicide.

It was then that I met Ole. He was a musician who played at "The Skipper". When I met him, I thought he was a bit of a jerk, nice and sweet, no matter how drunk and obnoxious the others were. We made love and I had my first orgasm. Holy shit! Who had ever dreamed of something so pure? It was a real boost for me.

There were times we just lay there and held hands, talked and listened to Billie Holiday. Thanks to him, I started to enjoy that kind of music. Right from the start, I knew we shouldn't move in together. That it should be without chains: Two independent individuals who were crazy about each other in their own special way. When we were out, I had to watch how much affection I showed because we weren't officially going together. I was so incredibly young and crazy and he was ten years older than me. I still can't believe that he could put up with me.

Love is the best activity your body can perform, in a physical and mental sense. It is the most wonderful, the purest, the most enjoyable thing because you experience that you share just as much as you receive. But it's got to be with somebody you really click with. Fucking in itself doesn't give a buzz at all. I've tried that so many times.

When you're on your own and aren't going with anyone, you need to express some of these human feelings, so you try to make content through fucking. Since I always hung out at "The Skipper", I usually was able to have a good time. After a couple of nights with the same guy, when things were starting to look a bit serious, I just didn't show up. I've known enough love affair misery: My aunt has fallen in love a couple of times but always with some worthless stuff. The married kind. They wouldn't leave home so she was left alone. I often wonder if I take after her.

When I started on drugs, I didn't give a thought to withdrawing. It never crossed my mind. Only when I met somebody who'd just been on withdrawal and felt great.

As long as you're pushing drugs, there's enough for yourself. And I always put some aside for a rainy day. Back then there were a lot of rainy days but not for me.

The successful pusher has to keep one eye out for the cops and be really a steady Joe and human towards her customers. Sometimes they're on the verge of death when they need a fix. With the sadistic pushers, they make you wait, the bastards. They just have a couple of other things to make you do first — straighten up, make the bed. Each second's like an hour until the bastard lets you buy the goddamn stuff.

A pusher had tremendous power, especially in the early 70s, when there wasn't much hard stuff. But after I'd answered the door, I had to say 'yes' to the customer even if I was about to take my own fix and even if it took hours. When this occurred, I had to stop what

I was doing four or five times because customers were at my doorstep.

So many I've seen don't know what pride is any more. You feel almost embarrassed to ask them what they're shooting. "If you aren't buying, then don't. You can screw yourself." That's how things are. The one with the dope is the king of kings.

While I was pushing drugs, my brother

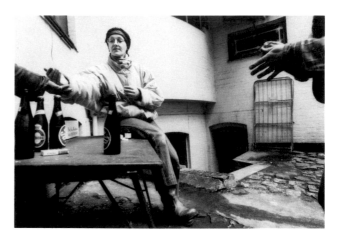

*Beth selling pills in the backyard
at the Vesty Boarding House*

Basse moved in with me. Basse was an addict too. He was incredibly grateful and felt good about being with me, obviously because I had drugs.

At the age of 25, I tried my frist withdrawal. I still had a ward and through her I got in touch with the Church's Salvation Army. It took me more than a year and a half before I really started to change. Right before this I'd been in jail in Sweden for two months because I got caught at customs with 10 grams of morphine-base. I got a suspended sentence

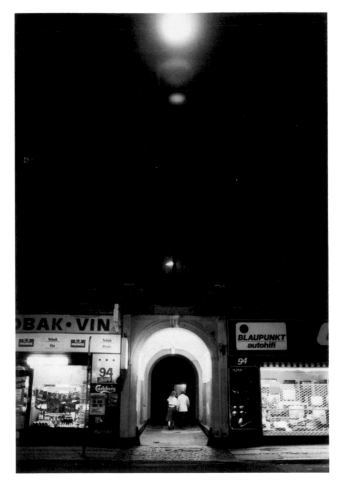

The Vesty Boarding House

through the Society for the Homeless. Earlier I had been given two years.

I wasn't really ready to withdraw. One thing or the other got in the way. So a year and a half went by. The week before I was hospitalized, Basse and I had run dry. I was forced to raise the cash for him and for me too. It was the first time since Halmtorvet. Fate would have it that I had to hit rock bottom to try to break the habit. I started crying and couldn't stop, got washed, but I couldn't get rid of those creepy feelings. The day after, I started walking the streets again.

Back then Basse was a great guy. He'd change the linen and try to give me a shot in the back of my arm where I couldn't reach myself.

Jørn from the Church's Salvation group got me. Basse had enough to last until the next day. He smiled at me, waved goodbye, and was really happy for me even though he was left to wallow in all the shit. I just felt that I should have the whole thing washed away.

I weighed only 49 kilos, ten below my normal weight. Two people from the Salvation group took me out to eat at an inn. But I was so weak and enervated that I got cramps and couldn't stand up. They were afraid to take me for withdrawal so I was taken to a hospital instead. At first I couldn't sleep at all and had to use a wheelchair when I wanted to get washed.

When they discharged me, I was 25 and wasn't hooked any more.

I got a job at an inn in the country, stole booze and gained 30 kilos within two months. Got as big as a house and didn't dare to show my face anywhere before dark.

That got me admitted to Sct. Hans (hospital for nervous disorders, ed.). Because the doctors thought I was using the place to lose weight, I only stayed for a week.

But I went back to Sct. Hans and started school again. In a year's time, I ran off from Sct. Hans because I got wind of the fact that my aunt had put my cat Buster to sleep. She was supposed to be taking care of him. That made me crazy.

They came to get me and I ran away again, got a hold of some sleeping pills and took an overdose of them. A girlfriend found me in time. I came out of it after five days at Bispebjerg Hospital, got discharged, and started to shoot up again. A month went by. I took some more pills. This time it took only two days, and when I came to I was in the crazy ward.

That second time I took an overdose, I didn't want to kill myself. I was just too proud to go crawling back to Sct. Hans to beg: "Please help me, I've reached rock bottom." I just couldn't get myself to do it. I try to be the tough one and I don't show anybody when I'm feeling down.

When I was released from this ward, I was supposed to start school again, right back to the starting point with a technical pre-high-school course. Somebody lent me a stinking, humid apartment with one chair, a little bed, and the toilet down in the yard. Got another apartment, started shooting up and playing hooky from school. I badly needed a home, a place where I could shut the door and feel secure.

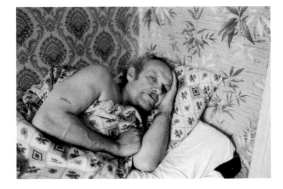

Poul

18

I got hooked again and headed back to the Church group where they gave me a quick and on-the-spot withdrawal with methadone. Didn't work. New attempt, taken to Hæsbjerg treatment center where I worked with other addicts. I did just fine there. A couple of us made plans to start a place to board animals. But then I started to shoot up a little again: We had absolutely nothing to do all day. Just sit and wait for a place to start boarding animals. And since we couldn't get a hold of anything, all our plans were shot to hell. I've been hooked ever since then and right now I'm on "horse" (heroin, ed.).

I was hooked for a while before I started working the streets again. I could get along on the welfare money and a couple of steady customers. I kept my habit to as little as possible but then I suddenly needed more and was forced to walk the streets at Halmtorvet.

If you're a hooker, you need an extra shot to be able to get through it all and then you need more and more.

I've always felt that I have had so many chances, maybe more than a lot of other people. Probably because I've always been very conscious of my own situation in life and I've gathered these experiences so that I can use them and develop. I'm a junkie, true, but there have been times when I've been off the stuff. Before I got the methadone, I honestly believed that I could stop shooting up if I could withdraw over a long time. And if and when I got off drugs, I'd surely start working for a school degree. On many occasions, I've gone back to school but I always leave again. Right now, many years have passed since I was back at school.

It's now eight years since I started taking

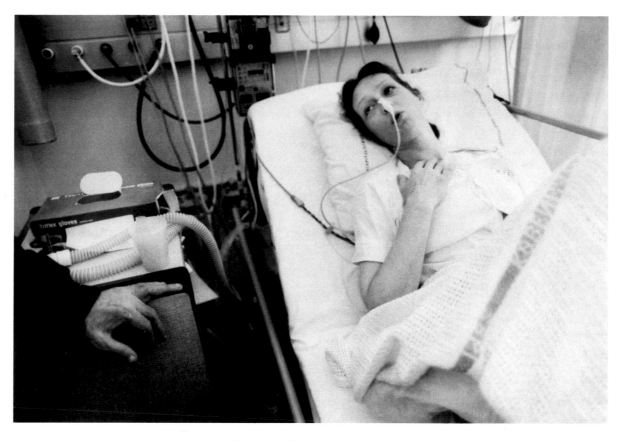

Kommune Hospital

methadone. It gives me constant depressions and insomnia. My head often feels like it's split in two. Even though I had hoped that methadone was going to be my savior, I didn't really want to start on it.

You can't do methadone all alone. When I started with it there wasn't a single person I could talk to. You need support and help from others in order to lead a normal life. For most people, things start out O.K. but everything turns humdrum and miserable. So you have a fix and then you need to start hooking again. On the other hand, without methadone I'd have to make even more money for my habit than I do now. So it gives you a little peace of mind.

During all the years I've gotten methadone from Freitag (the doctor who prescribes it for her, ed.), it's never been part of any genuine treatment. He's nice enough, but there's never enough time. Just like at the welfare office. You never have anybody to discuss your problems with and very often you're just referred to a new welfare person.

You can use methadone for withdrawal, but junkies shouldn't just have it palmed off on them as if it's lemonade. It's completely dangerous. Just let them get off the stuff and then leave them totally to themselves. I don't know how the people in charge go along with it.

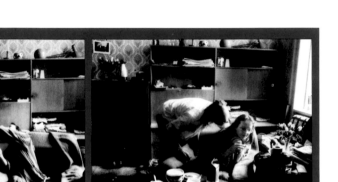

Breakfast at Poul's

Longterm junkies never ask for help. If they themselves are off the stuff and just want to stay off with methadone, that's O.K. But the authorities should expect something from them, they should be made to be active somehow and motivated to want to get rid of the habit.

When I first started taking methadone, I had good stretches. I got an apartment in Guldberg Street and that meant so much to me. But then I went ahead and sold much of what I had — vacuum cleaner and the television — that I really didn't like being there. Finally, I started living at a hotel in Isted Street. But the hotel had to be modernized and all of us were thrown out. I moved to a room at the Vesty Boarding House on Vesterbro Street — typical of me, at the very last

second. And that's where I've stayed.

Vesty ought to be torn down. You've got roaches and lice all over when things are really bad. During the winter, Per, who rents out the rooms, shuts off the heat whenever he feels like it. Often there's nothing but cold water. He takes advantage of all the poor people who live there. When they're broke, he'll lend them some money. When they can't pay up, he threatens to throw them out or forces them to do the jobs nobody else is willing to do. They all gripe among themselves but can't really do anything about it. So they kiss his ass and all that, just because he's got power over them.

Vesty is the last stop on the line. They all drop dead there. One of them wasn't discovered until someone found him 14 days later. Another said: "I'm going out now to burn myself in the garden." And he went right out to Søndermarken Park and burned himself to death. Nobody believed he'd do it. That's how these people are because they've got enough problems of their own. They get some sort of minor relief from their booze

just as I do from my drugs.

Those who aren't as far gone as us move within a month or two. Alfred was one of the few with a job and you bet he was as proud as a peacock about it. "I work at my goddamn job and I pay my taxes." Otherwise, everybody's on welfare.

Alfred died a half year ago. It was so strange when he suddenly was gone. I miss him. He was so reliable that you could set your clock by him. He had an extra set of my keys and it was really nice to be able to stop in at his place for a cup of coffee and some t.v. We could keep quiet together. And I couldn't wheedle Alfred to do something which he didn't really want to do. It was great. He was just himself, and I felt so secure with him because he really knew me. He was aware that I was on drugs and knew I could be undependable. I could borrow money from him and he was always sure of getting it back, better late than never. He needed me just as much as I needed him.

Alfred didn't want to pay me for sex. We were neighbours. I'd get 20 crowns for cigarettes when I went shopping for him. He had trouble walking. But it all started with me suggesting that if he'd lend me 100 crowns, I'd give him a little. I only got 50 and he only got less than a little. It all started with a little but things developed pretty soon. A bit of change for a bite to eat and some cigarettes. It was that innocent. But that's the direct route to ruining a relationship with a next-door neighbour. It would have been better to borrow and pay back.

Poul had lived at the Home for Men and moved into the room next door. He put some glasses he'd won near the telephone and

wrote a note: "I won these in Tivoli and don't need them myself." I think it was a really cool thing to do. And he left newspapers there where the others could read them.

Alfred got jealous when I visited Poul instead of sitting and entertaining him with chat and coffee. With Poul I got money for dope in advance and in return I promised him a lay at some point.

It was a time when I shot up, "worked" a bit, and then shot up some more. I was really low. I had no strength left and was about to leave this world. I took sleeping pills, Allypropymal. Not to kill myself but to sleep off the no-fix crash. I left a note for Poul: "Let me be. I'm just taking a nap." But it didn't work and I headed straight with an ambulance to Kommune Hospital. When I came to, just about everything was wrong: pneumonia, ulcer, and something wrong with my heart. I don't remember the fourth problem.

I lay there with withdrawal pains, completely awake, sick as a dog and with a guilty conscience about having caused the whole mess myself. My mind was all screwed up and my thoughts wandered: What am I going to do? How come I don't feel the methadone?

At last I couldn't stand it any more, pulled the tubes out, gathered my stuff, and left the place at 2:30 a.m. I moved in with Poul. He picked up my methadone, made sure there were cigarettes, coffee and something to eat. I was seriously ill and felt the writing in the newspapers was upside down. I was afraid my brain had been injured for good. If that is kaput, if you can't figure things out yourself, you'd might as well be dead.

I was treated like a queen. I was so low that it didn't bother me. And Poul's not the type who puts the clamps on to get a fuck. I felt relaxed about letting him take care of everything, even the methadone, which he made sure I got. Everything he did was for me. I was his whole life. Poul had gotten enough energy to help me and that's why I had no guilt feelings. I got involved in myself and in getting back into shape again.

Poul wanted me to be his woman. To become his girlfriend. He accepted my world as his own and let it take over. As I got into better shape, I started making decisions, and I guess I alienated him more and more instead of trying to get closer so we could help each other out. He couldn't accept the fact that I let him lay me to get the dough for dope. I just can't mix business and friendship. It doesn't work for me.

All along I've said that I can't let myself get into bad shape again. But it seems like I'm always pulled down into the shit. The truth is that things have been getting rotten for years. After I hit 30, things have gone from bad to

Isted Street (red-light district)

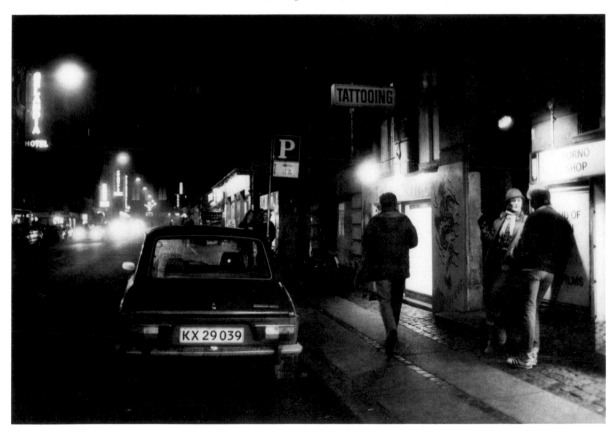

worse.

I've always set really high goals for my life, but during the last couple of years I've been in really bad shape for long stretches and stuck in bed. The pits are my crashes. I get cramps and am dizzy all over and throw up. I can't lie down, can't stand up and can't do anything constructive.

I've been in lousy shape because of my earlier life. Occasionally I get a bite to eat, a couple of rolls or something else from the baker's. There is a kitchen here but it's filthy and ice cold so I need my overcoat on when I'm out there during the winter. I take vitamin pills each day but I can't go on living on them.

I've been hospitalized a number of times. There was the night a doctor threatened to amputate my leg 'cause of an infected leg wound which drove me crazy with pain. Sometimes I couldn't even walk. I got it shooting Abalgin. I must have shot into a vein and my leg blew up to the size of my thigh.

With each hospitalization, I've gotten myself discharged as soon as possible. Even though I get my methadone there, I can't stand hospital environments. Hospitals are out for me when I'm real down. All I want to do is hide when I feel like that. Disappear.

I've lost most of my uppers. One right after the other, suddenly. I never got to the dentist although I made plenty of appointments.

Every two weeks, I pick up my check at "Lasen" (welfare, ed.). So I have to wash all over 'cause I'm out on the streets and with others.

Each day I have to go to the drugstore to pick up my methadone — but that's another

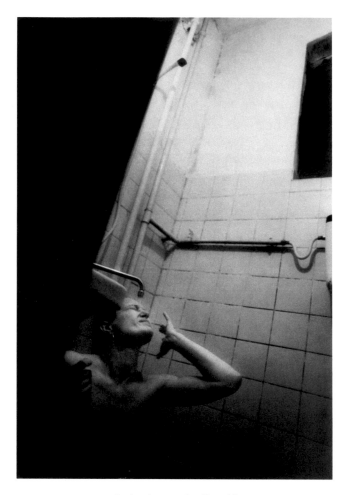

In the shower after "work"

story. I just brush my teeth and throw a scarf over my dirty hair.

I get 3.200 crowns a month in welfare. My rent is 1.100 crowns and they pay that. My methadone and nerve pills are free. I'm real lucky in that way. When I pick up my welfare money, I bike around and pay up my debts. Then I can get what I need at the baker's, pick up smokes at the candy store and magazines at the newsstands. I enjoy seeing the good old faces, hearing the latest gossip from them — it's a vital thing for me. When I watch tv, I know exactly what's going on. I also enjoy seeing color pictures of some really gorgeous gals, just like you'd dream of looking.

Usually I get what I need in the way of flowers, shoes and clothes by stealing. The money just doesn't stretch very far. Who in God's name can make 1.000 crowns last two weeks? You have to have something to wear, detergents to clean the room with, and food. Anything unexpected makes you get into debt. It might be a fine of a few hundred crowns. And then the cops show up about some unpaid fines I can't even remember. If I don't pay up, it's jail for a couple of days.

Indictment page 23

Copenhagen City Court – Lisbeth Sigrid R.
§ 287, § 276 – theft,

Friday, the fourth of June 1982, 0300 o'clock at the Vesty Boarding House, Vesterbro Street 94, room 311, in connection with prostitution, alleged to have stolen a wallet belonging to Erling Pedersen, containing about 550 crowns in cash—Danish, Norwegian and Faroese money—plus various personal papers to a total estimated value of 620.–

Police Department of Copenhagen Oktober 10th, 1983.

You can shove it up where I stick up when I'm picking strawberries!!
That's it! Everything is now told!!

1/th

Anklageskrift.
Genpart.

01K5-75612-02610-82
P. s. j. nr. _____

023674 **1983**

Byrets j. nr. _____
f.

Fr. Lisbeth Sigrid R

Vesterbrogade 94, vær. 311, pens. Vesty,

1620 København V.

Personnr. (evt. fødselsdato og -år) Fødested

22 04 49 - 0468 København

sættes herved under tiltale ved Københavns Byret til straf for overtrædelse af

straffelovens § 287, jfr. § 276 - tyveri,

ved fredag den 4. juni 1982 kl. ca. 0300 i pension "Vesty", Vester-
brogade 94, værelse 311, i forbindelse med et utugtsforhold, at have
stjålet en Erling Pedersen tilhørende tegnebog indeholdende ca. 550 kr.
i kontanter-danske, norske og færøske penge - samt diverse personlige
papirer til en samlet værdi af ca. 620,- kr.

<u>Erstatningspåstand vil blive nedlagt under sagen.</u>

I kan rende mig der,
hvor jeg er højst når jeg
plukker jer 600 !!

sådan !
alt er
hermed sagt !!

Københavns politi, den **10 OKT. 1983**

P. p. v.

M. Jørgensen

politiadvokat

Retsmødet afholdes i Københavns byrets**17**.... afdeling, Domhuset, Nytorv/~~Domhusets anneks, Slutterigade~~

Porten til højre for hovedindg.

MANDAG d. 16 JAN. 1984 Kl. *11 00

It was my idea that the welfare office pay my rent directly. Before that I'd get all the money and it was just like Christmas again: I didn't have a rational thought in my head and all the dough went towards junk. I was real good at convincing myself that I'd just pick up someone so I could pay the rent or a debt. I always find myself buying drugs for the money.

I always get going at the very last minute when nothing else is possible. I search for a hiding spot inside myself for all my feelings; instead this germ of imagination gets loose and gets under my skin and it goes downstairs and earns the money for me.

I just have to wash and straighten up: Everything throws off my rhythm. What I prefer is being all alone and imagining that now…

I always walk to "my street" even when I can afford a cab. When people pass me on the street, I look in the windows, preferably with a butt in my mouth, looking cool. I'm embarrassed so I go down late at night to avoid all the tourists. I can take the guys but not with their wives. It's degrading.

It's 200 crowns for a "Danish massage", a hand job, and 400 for a lay. I rarely fuck them. If it does happen, I'm on top. One thing I can't take is his sweaty, creepy body on top of mine. Since the AIDS scare, every one has been with rubbers. And they don't get to kiss me either, but then again, they never did.

Usually its 400 to 800 a shot. Either a hand job or a blow job. If they want to go down on me, that's extra. If they want more, they have to pay for it. It's a quick buck, it stinks, and I don't give a damn about it.

When I walk the streets late, it's often alone. The others are through for the day and I can take longer to choose, though they're dirty pigs. I can't unwind if they stay in my room overnight. It's like working 'round the clock.

After the last John, I go right into the shower. Rub and scrub to get the dirt off but it never disappears: It's inside of me.

I've never enjoyed walking the streets. That's why I call Johns "bulls". They're simply not people for me, no matter how kind they are towards me or me towards them. Many of them are simply lonely. They're here with some money to blow to get some pussy. But if they feel I'm just a plain, nice girl, like I pretend, they pay for tenderness and love, which I can't give them.

When I talk about myself, the tape recording in my brain automatically starts: "I live in Roskilde and am a student. A doctor and a lawyer with their respective wives live in a fully-paid-for house on the second floor. They always have a young student renting a room on the ground floor: That's where I come in. In the basement there's an architect. There are four bathrooms for us. The architect and me play ping-pong rather often and

Alfred in his room

24

he's often wild because he loses to me. On the other hand, he beats me at chess. He's simply too good at that. I've got my own adorable room with a tiny kitchen and a little toilet and which I've insulated (for sound, ed.). Then there are my three cats and a den which is more like a library with an old tv. If we feel like getting together we often sit there. We are mature adults who don't like to be disturbed all the time. If you lock your door, that's respected. They'll only knock on it when someone calls you on the phone. The doctor's wife is a social worker and the lawyer's a dentist. By the way, she's promised to fix my teeth real cheap. She's going to do it when she's off work and I just have to pay for the materials.''

It's usually the front tooth and perhaps the little one next to it which need working on. You see, they can't see more than those missing. If someone asks, which thank God happens once in a blue moon. I say it was a childhood accident. I'm always on my way to the dentist. With every new "bull" even four years back.

"This room here? I've borrowed it from a girlfriend, a single mother with a child whose with her own parents just now. I pay 200 crowns for the room for a night and I have to pay up because I've been out getting drunk and have fallen behind with the rent.''

It's eternally the exact same story with very tiny variations.

Most of the Johns are scared and insecure and they come from all different social groups. I've had lawyers, doctors, bank people and just plain working men.

Then there are the weirdos: I've always preferred those who want to be whipped or peed into their mouths, as they didn't want to touch me.

Many of them just want you to be a good ear. I've had many a John who just patted my hand, passed over 200 crowns, and said that he didn't want to anyhow. He felt I was all too sweet for this life. They enjoy that. But I can't get by on that. I need the dough and I can only think of one thing: dope.

If I'm real hard-up for the money, I have to steal from him. I've done it many a time. Then there's the guy who wants the whole show, a night of it without paying up what it costs. That's when I get nasty. Instead of tossing him out on his ass and not making a buck, I crush three pills into his beer glass and then he sleeps tight. Then I check through his pockets for his money. When he comes to, it's out on his ear as he's been here too long, and I threaten him with the muscleman I borrowed the place from that very night. If he makes problems, I'll just call the police, or "the garbage collectors", as I call them.

The perfect "bull" is the guy who knows exactly what he wants and will pay the price so I don't have to turn on the act for him. It's one, two, three, so I can remove him — and my feelings of guilt. But often they think they've paid for love too. They get the idea they can buy all of me, the outside and the inside, when it's the lay he's paid for. That's just not me.

When you have your regular "bulls", it's a pain in the ass, 'cause they hope they have found their own woman. There was Henry with lots of dough but he worked around the clock. When we didn't get together any more, he didn't have any more money in the bank.

Of course he was lonely and needed a woman and I used the fact that he hoped we had a future. When he saw there wasn't any hope, he got a lay once in a while.

I've had only a few regular customers 'cause the better you know somebody, the less you enjoy cheating them. And you can only think about dough and dope. It doesn't

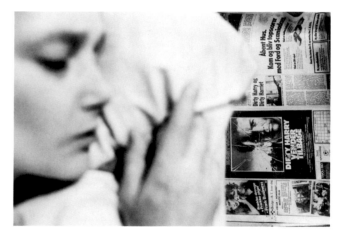

After taking her fix,
Beth nods off with a cigarette

matter about the money but you need it for dope. It's like double exploitation — the dope and of your fellow man. The more you take them by the nose, the more miserable you feel. 'Cause it's cruel and lousy.

Tove was someone I didn't use in that way. I've known her since I was 20. She was 100% gay and for a long while I thought I was too. I don't really know why: I've always gone with men.

By the age of 16, I'd had a relationship with a girl. Later on around here, all the girls

25

would fight over me in the toilet. It was a nice and very flattering feeling. I can get just as worked up over a woman as over a man, but I feel what's right for me is men. I think I'm bisexual.

When it had just started, it was all new and exciting. Tove loved me with all her heart. She was a breath of fresh air and had nothing to do with dope. We started going together, as much as that was possible, 'cause I needed to go down for the dope. And right after I'd been down to pick up a customer, I couldn't see her. I couldn't streetwalk and have a true love: It's a filthy feeling. It's not the fucking a customer but that you filthy yourself emotionally.

When she and I made it together, I could give the most. Emotionally . . . O.K., we were lovers, we hugged and touched as one does. But I wasn't really alive. I liked her so much. It had nothing at all to do with her. I was just incapable of loving. That part of me was stone dead.

If you've gotten a fix and you have another for tomorrow, you feel safe and you can open up. But it's the stuff which liberates your feelings. You're a good person, you aren't going through withdrawal. It's the junk, not you, which calls the plays. You feel nice and kind and courteous but right deep down you can't, you're just a robot.

I felt like I was trapped in a glass jar so I went out to Tove. I could give her a hug but she couldn't reach me. There was a wall of shatterproof glass caused by the dope.

Tove was a secretary to a doctor and made good money, and she asked me to move in with her. I'd get money for dope. I just couldn't go along with it. Cigarettes and food

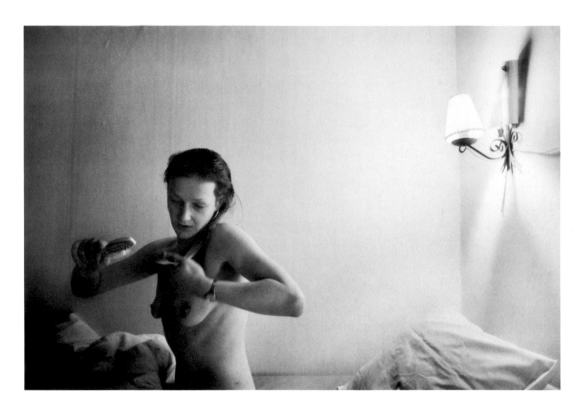

when I was over but never money for dope: I knew that if I accepted just once, I'd start exploiting her and never see her again.

I was nice and kind but that wasn't enough when I knew she was in love with me. At last she got so unpredictable that she would take a day off once in a while just to be with me when I finally showed up. If I'd hung around, I'd have pulled her down with me into the shit. Just like that.

Christ, she wanted everything to be wonderful and I wasn't able to give her anything. I just left.

The drug scene's become tougher and har-

der: The me-first attitude 'cause even a little dope is worth big money. A fix goes for 1.000 crowns. In the old days, you'd get together with each other but these days I don't know a junkie who can get together with others socially after "working hours". It's much tougher these days to get the dough for your habit.

Violence has increased. I guess I've felt more violence myself the last five years than during the first eleven. One example is how I got some nerves in my hand cut up by a guy who couldn't "come". So he pulled out a knife and in the tussle I knifed him in his spleen. And I've been kicked. And there are

fights between the girls to gain respect or about customers or about prices. They get jealous of each other when they've been down a couple of hours without an offer.

I have a knife on me when I'm down. Preferably a switchblade 'cause it frightens them. Just the thought that it's in my pocket makes me feel a tiny bit safer. Each day there's violence but I've been lucky and kept out of trouble even though I've been forced to go along with a lay for 200 crowns just to manage a tight situation.

I'm always afraid afterwards. It gets harder and harder to go downstairs and pull in the money 'cause my physical energy isn't what it used to be. I have to be just as tough about murder as about laying all types. All my own toughness twists me even more than other people's toughness.

"Beth, can I come in? For 10 minutes. Just for a cigarette?"

"Basse, it's no good 'cause you can't manage with that. When you finish one cigarette, you start another and then you just have to do this and then that."

My brother's as grateful as hell if I let him come in. I let him but only if I've gotten my fix. He needed me but I shoved him away. Either I was down making some dough or else I was sick as a dog. I didn't have the patience for him. It sounds like excuses but it's true. You only are above water when you have your junk.

Basse was the part of my family I've known best since I've been hooked. We hung around together. He moved into the Vesty even though he had an apartment in Valby: He wanted to live near me, but I

couldn't stand the sight of him and I hoped he'd move out. He was always so goddamn drunk and high. He was a junkie and a drunk. Once completely drunk in the middle of the night, he knocked on my door and yelled: "Goddamn you, if it hadn't been for you I wouldn't be in this fucking mess. I hope you really feel miserable about it."

I can't help thinking whether he was into becoming a junkie when he saw how I lived: The first years were terrific. I always had dope and lots of possibilities.

A few hours later after he'd had his fix and had calmed down, we sat and talked. "I think I'll roll over and die before you, Beth", he said calmly.

I can't count the number of times I've looked out of the window and seen him in the yard laying on a filthy sofa in the rain. He had turned blue. It hurt me so goddamn much, but I blocked out my feelings. They weren't allowed to show. That's why junkies get into so much shit: You get apathetic.

Last time he was here he brought along a pal. No junkies were allowed here. They

Dear Dear Tina and Kent

Beth says, what one doesn't say
and hushes up, what isn't hushed up
to friends who perceive
and kick swiftly
so nothing escapes them,
when one sees
one can walk upright
perhaps with a limp
so what?—a start
with no age to it,
freedom without a limit,
unlimited drive of living—yours
choose—Yes, we will survive
alive and in this life.

Thanks... TINA and KENT for
your friendship. THANKS.

wanted to borrow some "tools", big pumps 'cause they'd called the doctor on duty and believed they could get Ketogan. Right after they'd had their fix they promised to come by with a fix for me. Of course Basse went first: Then he passed out and lay in front of an open window and got pneumonia without feeling a thing 'cause he was stoned. That's how he kicked the bucket.

I've seen so many corpses but this one was my brother. The others who passed on around me weren't people I was attached to. If you feel like a piece of shit, you can't react emotionally towards anyone but yourself. There's no such thing as junkie friendships: Only acquaintances and forced on us because of drugs.

I took my shot, then another right after I heard that Basse was dead. I couldn't feel either of them. I was a bundle of nerves. Maybe it was for the best — but I miss him.

I've never been afraid of dying. It's *how* that matters. I won't kick off from an overdose 'cause you suffer like crazy. You have all those waking moments with the cramps. And if you're with others, you're a burden for them.

Today I don't feel like dying. There are too many things I've messed up on but I can't change them. But I'll get things fixed up as much as I can.

During the last two years I've tried to withdraw. With mixed results. I finally felt that I needed a total change in order to do it. Either/or. I couldn't get any lower than where I was. I didn't want to take occasional shots and get sick. I would take Sovinal and would end it all. No doubt about that.

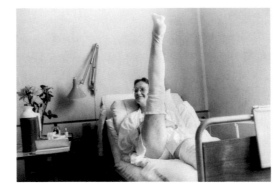

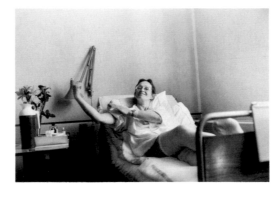

This is the last chapter until now on Beth. I won't stop hoping that despite all she's been through that basic drive will bring her above water. Let's see, there's probably more to come.

SH/IH

Excerpt from the journal.

Then I messed up my cervix and was admitted to Bispebjerg for an operation. I was shitting bullets. Not because they wanted to take it all out but about how the others would look at me. I wasn't anything but a goddamn hooked streetwalker, self-destructive, and a loser, and I was going to be among all types of people from totally different worlds.

If you're hooked, then you're a prossie and a thief. Nobody trusts you: You're rotten to the core.

Thank God, I got my methadone right away and didn't get the crash when I was admitted. The other times I'd been hospitalized, I ran out as soon as I could stand upright. But this time I was treated like everyone else, like the individual I was. It was great.

An entire month in the hospital by choice. True it was at the last minute but I made it. It was a giant turning point in becoming normal. Now I want to try to get off the habit, off heroin, cut back on my methadone. Nice and easy.

It's like being young again. Young but with too much savy about useless things. I thought I knew a lot about society but the little drop I know can't fill a thimble. I don't feel bad about how little I know, but I'm embarrassed about being 36 and such a chatterer.

When I'm only on methadone, I talk to people on the way to the drugstore — about everything. They open up 'cause I do. That's when I don't feel totally like a loser and that I'm still a good person.

I'd like to visit Dad more often. Show him my good side so he'll have a little to make him happy. He needs to feel that one of us is doing O.K. He's been let down so often. I really

hope he hasn't given me up for lost.

I also have to fix my room. I don't like to have guests with the way it looks now. But what I dream of most of all is to move where there's a shower with hot-and-cold running water. It would be luxury for me.

I don't feel bad about living in this room, but I want to get out of the area 'cause it's not giving me anything.

I'm great at making excuses when I've messed up: I don't know what happens. The last time I biked back from Poul's, I was sad and depressed. I felt everything was hopeless and I was on my way back to the misery. Then I got the idea: I'll fix on methadone, the idea came to me just like that. Then I had something to look forward to.

I've emptied the drawer many times and the pumps are back. I must stop shooting up the methadone. I'm now down from 12 to 6. I have to cut down and stop procrastinating.

I've often thought about what could have been different. My insecurity is the real reason I started on drugs. At 17 I was restless, lonely and full of complexes.

For the first half of my life I'd been locked up in institutions, the second part I've been a junkie. But I've always felt it was all my own fault and that's why I've had a hard time asking for help.

All that about kids not being happy in institutions isn't true. It would be healthy to live in a family but that was the only one I had. There wasn't any security at home — and a kid needs that badly.

If my Mother and Dad had liked each other, if they'd had better opportunities, things would look different. But they had to fight to survive and didn't have the time or the ener-gy for us kids. We were forced to make it on our own. My Mother hurt me so much. When we lived in the barracks and Dad worked nights, Mother had men over. I was seven or eight and she called me in so they could touch me. I started crying but couldn't cry too loud 'cause if I did, she said she'd hit me. Any little thing I did got me a beating. I yearned to come into her room so we could make up. But it didn't matter what I did: It was always wrong. After a while I didn't dare to do anything at all: I was on guard all the time.

Dad gave me what I didn't get as a child from her. I love him. He's really tried just about everything possible. He's always been a fighter and the result is he's a broken man, physically. But he still has a good soul. I hang on to Dad 'cause he is made of the right stuff, but I also know about his faults. If I'd gotten into trouble, I got a couple of smacks and then it was all over. Afterwards he was sweet as sugar and nice again.

I always tried to excuse my Mother towards Dad. No matter how much she took out on me, I never told Dad: It would have been a pity if he'd known how she really was.

My Mother had the will to live but I don't think she ever lived the way she'd dreamed of.

Once, in Klokke Street, my Mother and Dad were having a battle. Dad beat her to the ground. First she stood there with a knife and then he got it from her. I tried to push him away but he gave me a couple of smacks. Then I woke up the other kids and I wanted to separate them. He was real close to messing up totally.

What I remember is that she was grateful: Genuinely and truly. But when I protected her I didn't do it for her but so that Dad wouldn't go overboard.

Whenever I try to get off drugs I get all these feelings which I assumed I'd forgotten: For better or for worse. They simply ooze up in me.

I've always fought for a place to be part of. Just like the time Mother and her new boyfriend drove me to Halmtorvet. Right after my parents' divorce. We were out for a drive and sat in the car, staring at all the hookers. I was so overjoyed that she suddenly cared about me. I jumped out and whipped up a John and his money so there were rounds of beer for us all. I wanted to: I was so goddamn happy and relished treating them. But it didn't last long. She was so sweet to me 'cause there was money floating around.

I'm not bitter now. But there have been many times where she's been so cruel to me and I ask myself why. The worst part is becoming hardened. It hurts to have feelings when you aren't allowed to give vent to them. But I have to accept these conditions. I just want to live my own life now as I want it: I just *have* to.

As told by Beth, in the summer of 1985.

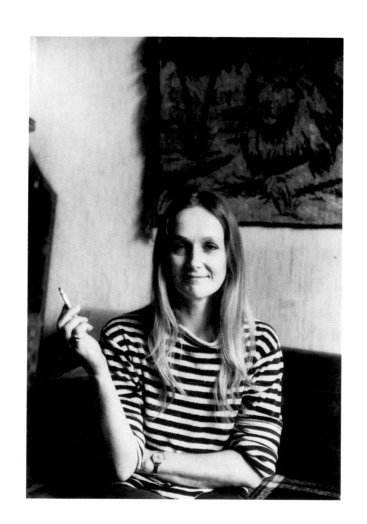

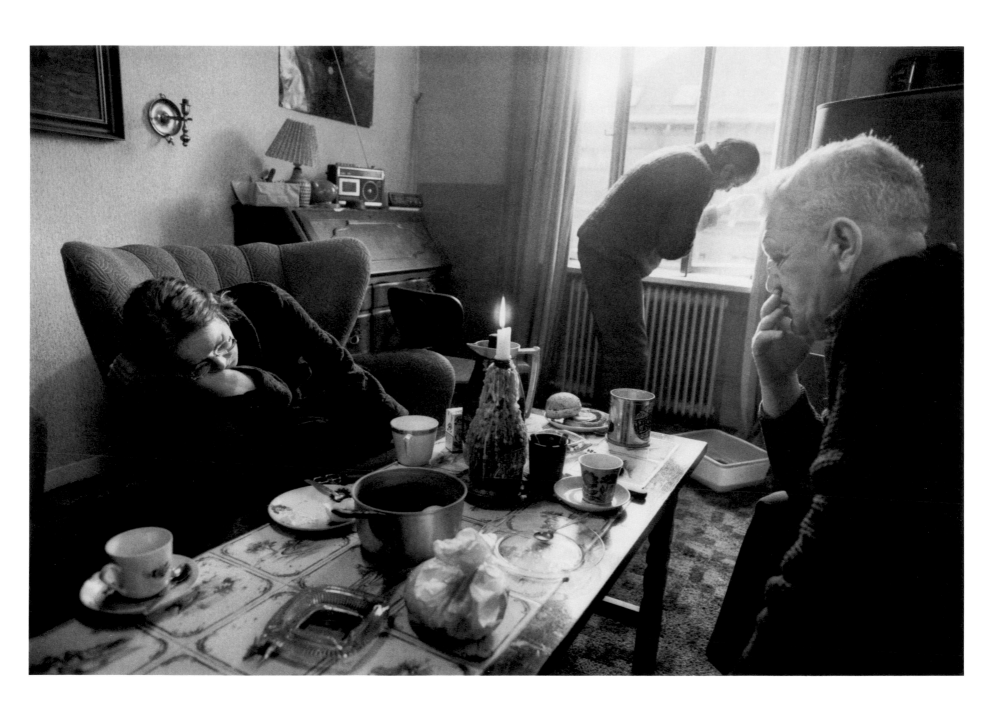

Saturday Coffee at Alfred's

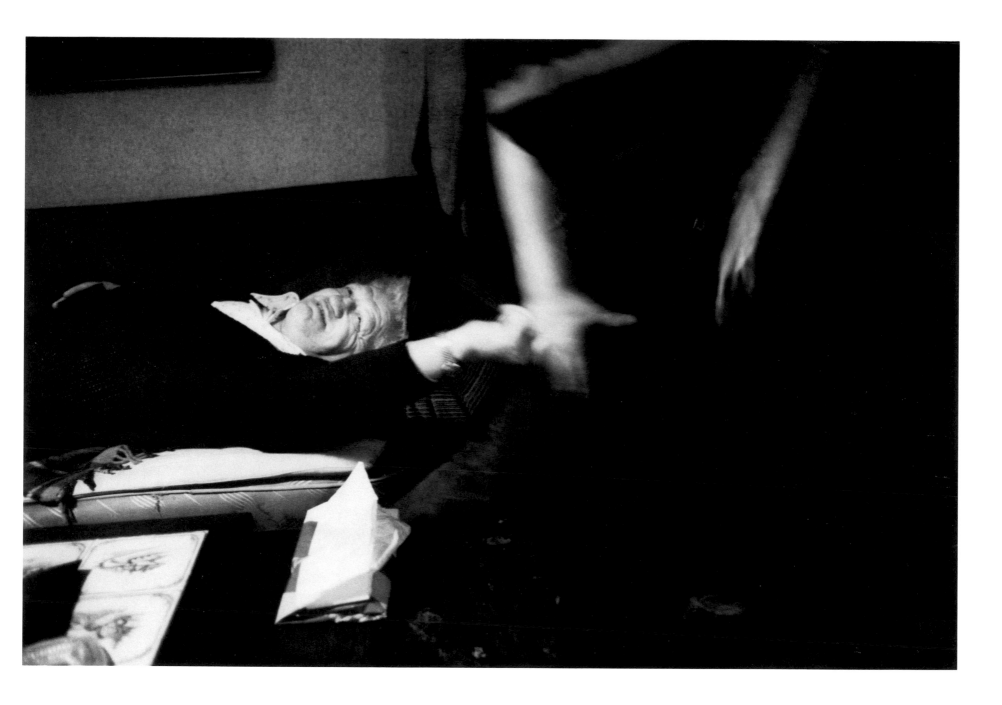

Alfred

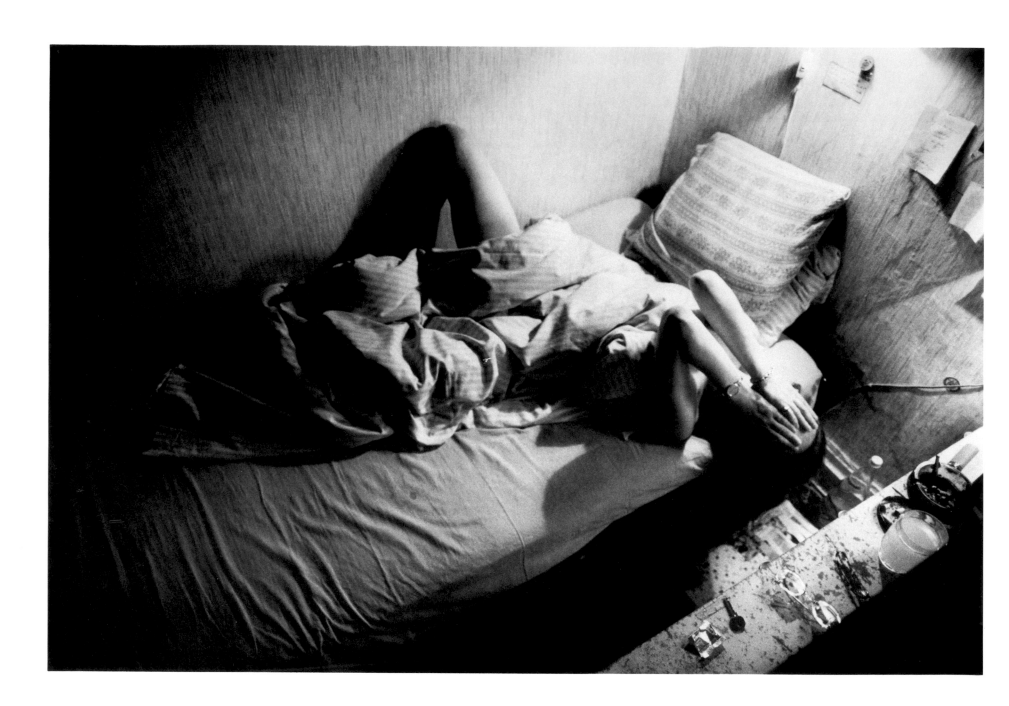

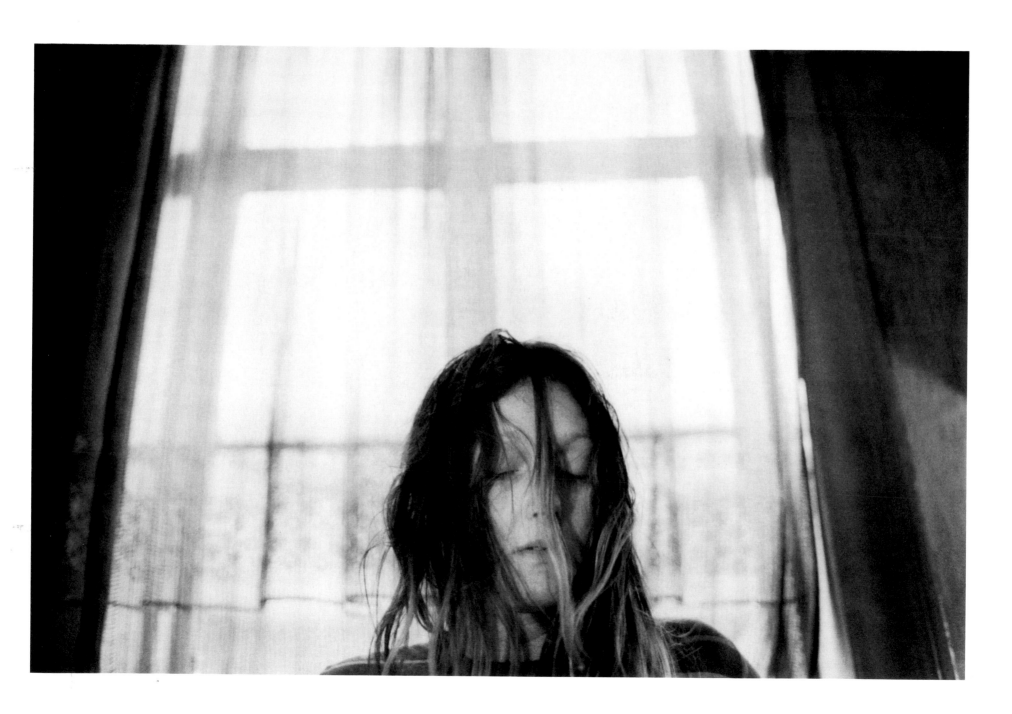

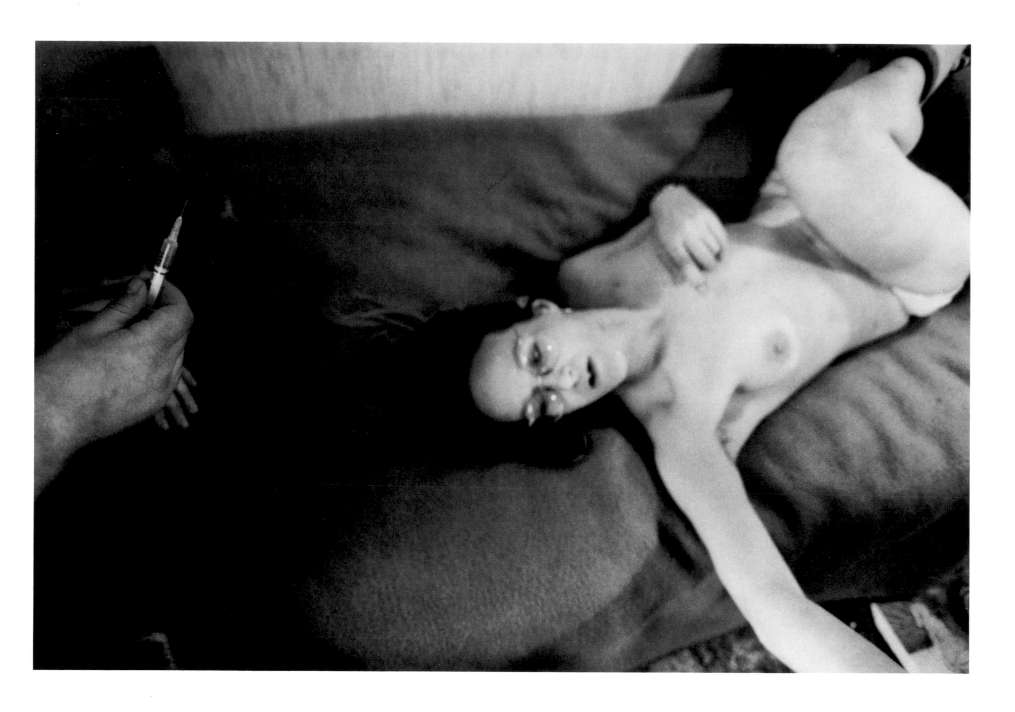

Beth is helped to take her fix

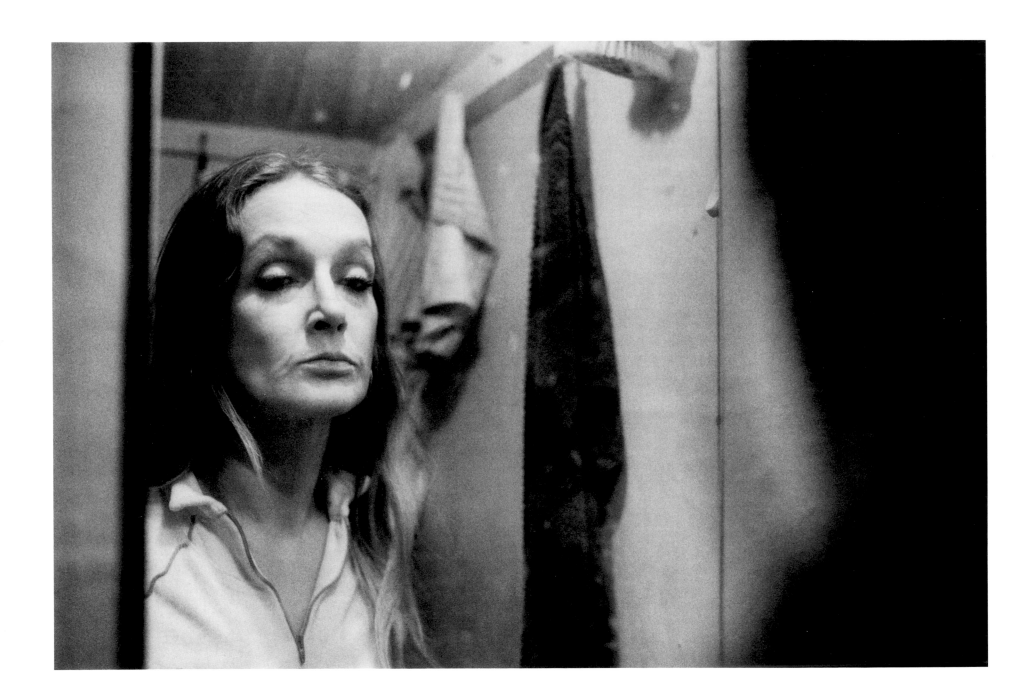

Halmtorvet

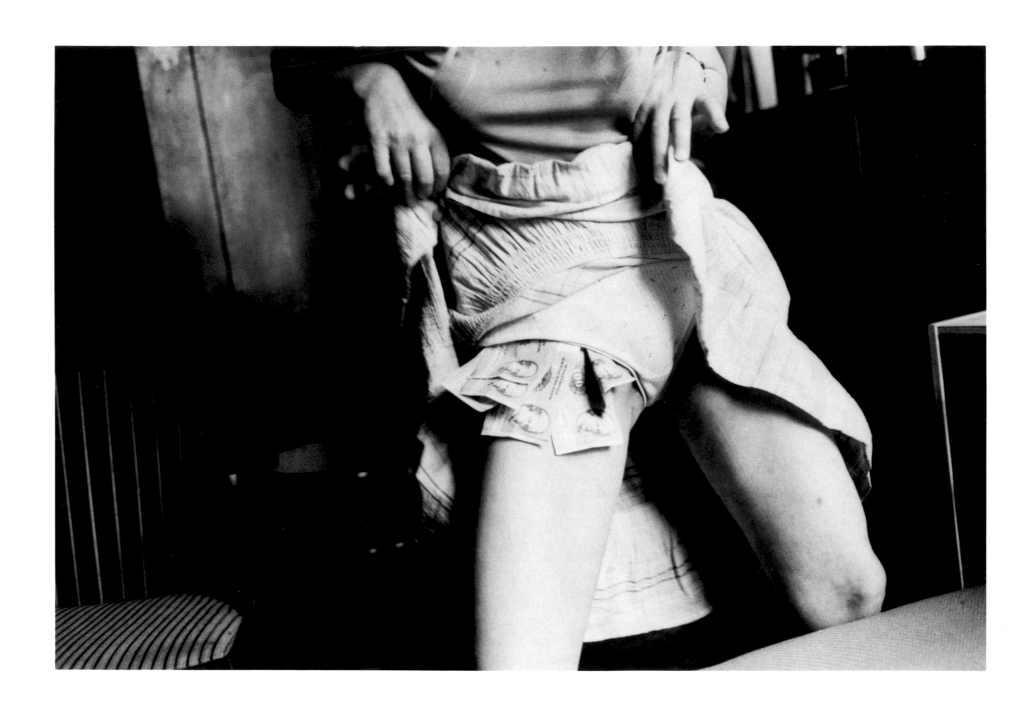

It's been a good night with lots of money

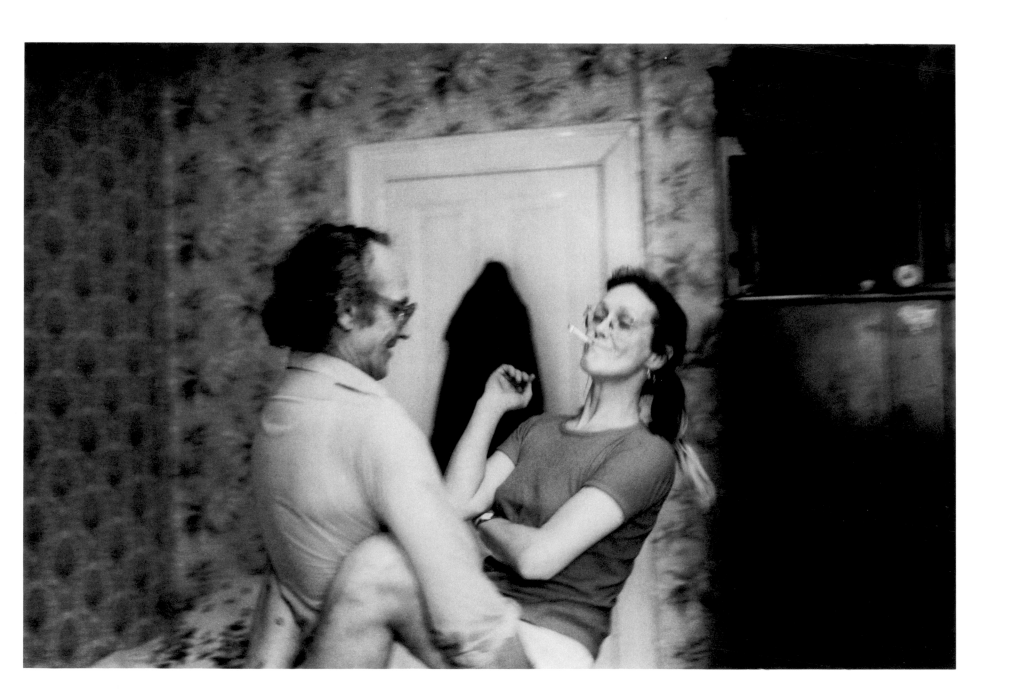

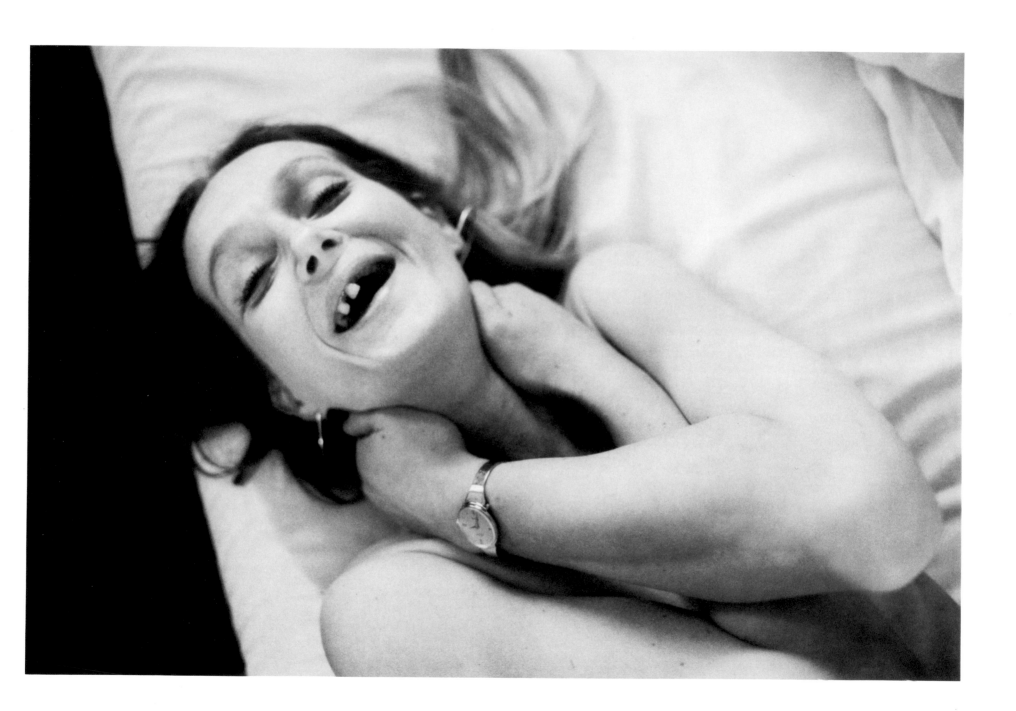

From her diary.

She pees in the sink and washes her clothes
in a pail. She wasted a lot of time and
energy washing around each time she had
to urinate that she hardly could sit up. But
making in bed was of course even more
difficult. Hah, it would have been quite
easier if she'd done it the other way 'round,
just pulling a string even with her laziness.
She laughed to herself and decided to try
the easiest way... next time.

(handwritten diary in Danish)

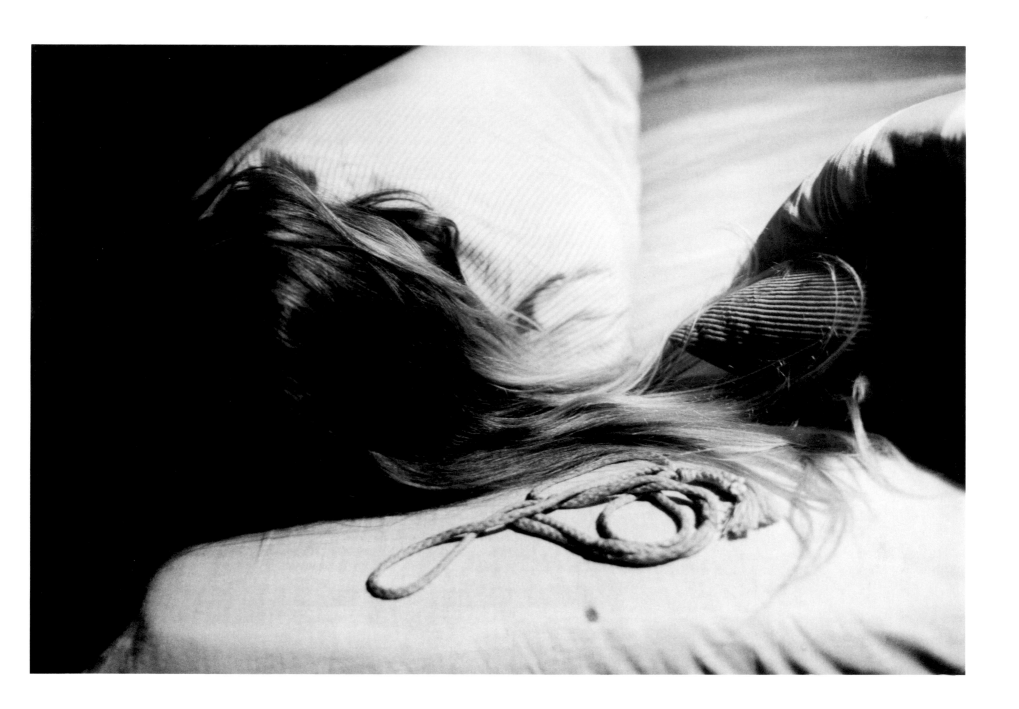

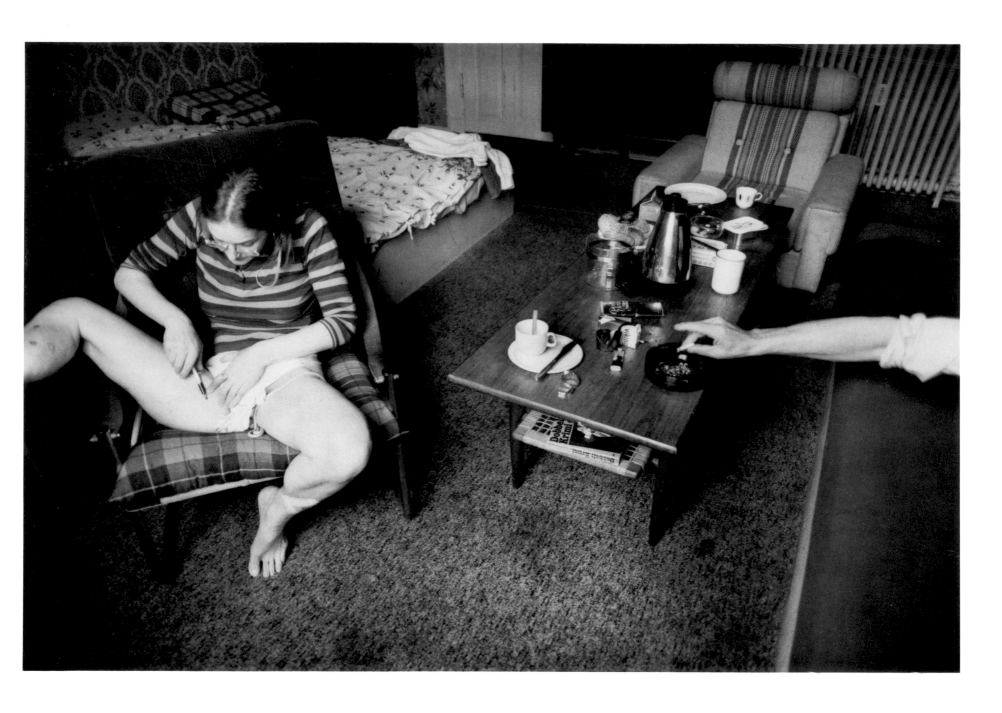

Breakfast at Poul's

A shot in the neck

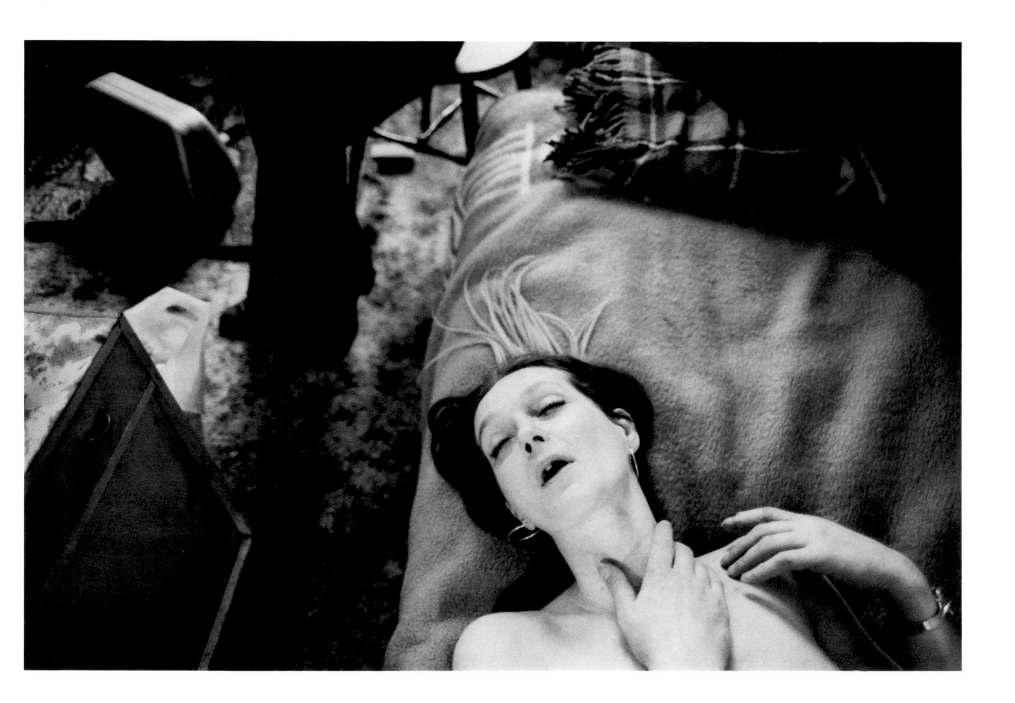

Thought I had 10
but had 40
don't be n
nervous

don't be nervous
can't sleep, thought

hvoere

jeg hav 10

men haufe 40
bliv ikke n
nervøs

bliv ikke nervøs-kan
ikke sove hvoerde h.

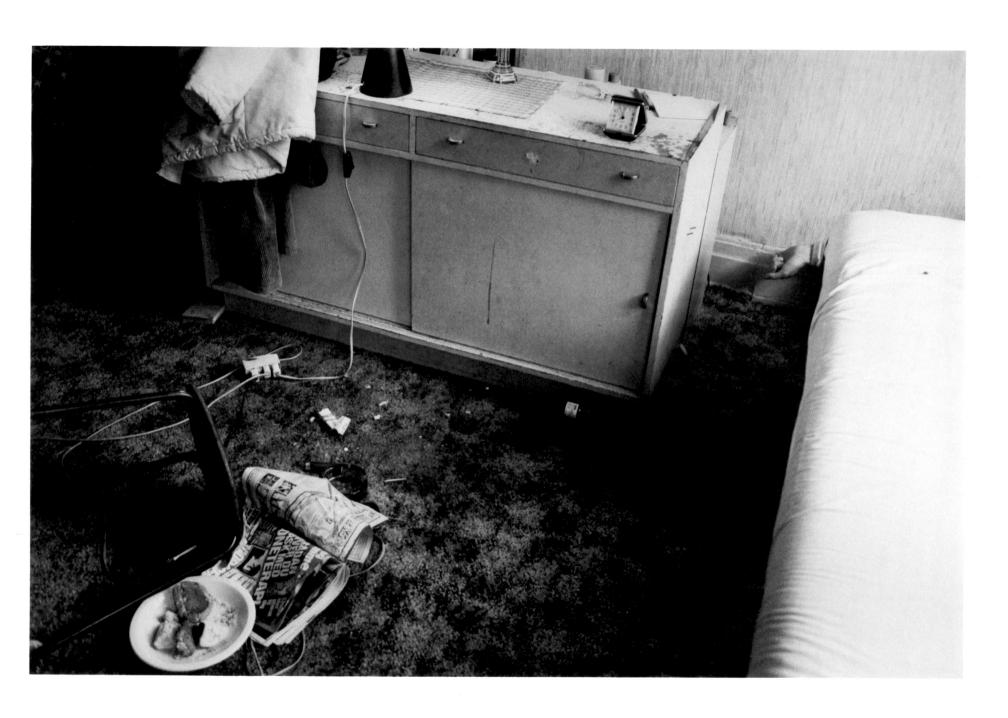

Beth took sleeping pills to get her through a crash

Well-known drug addict admitted to hospital with fresh needle marks
and an empty pill bottle.
The patient put on tubes briefly because of insufficient respiration.
Diagnosis: pneumonia and initial stages of anhypen treated.
On the left lower part of the leg an infection which is opened and
bound.
After 3 days, patient is completely aware and is leaving the ward
without official discharge.

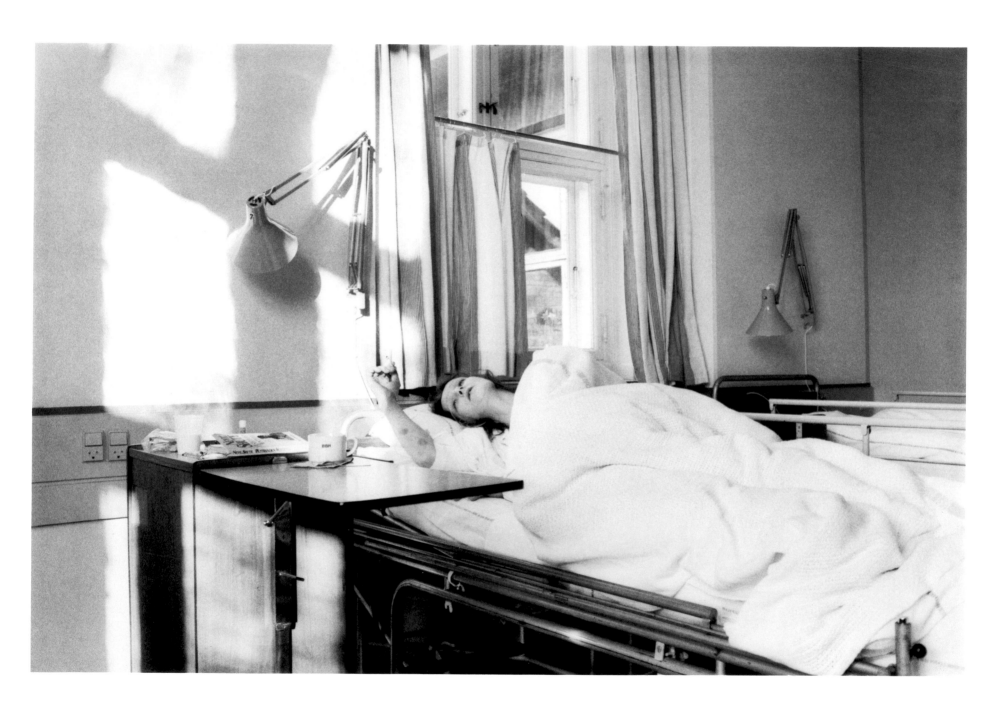

Bispebjerg Hospital

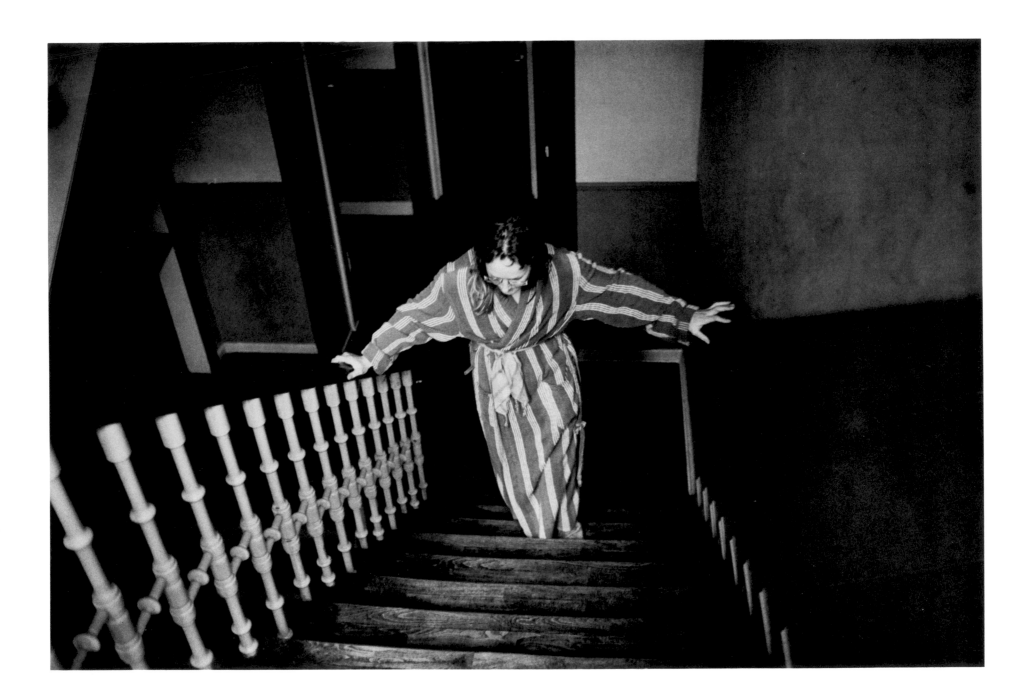

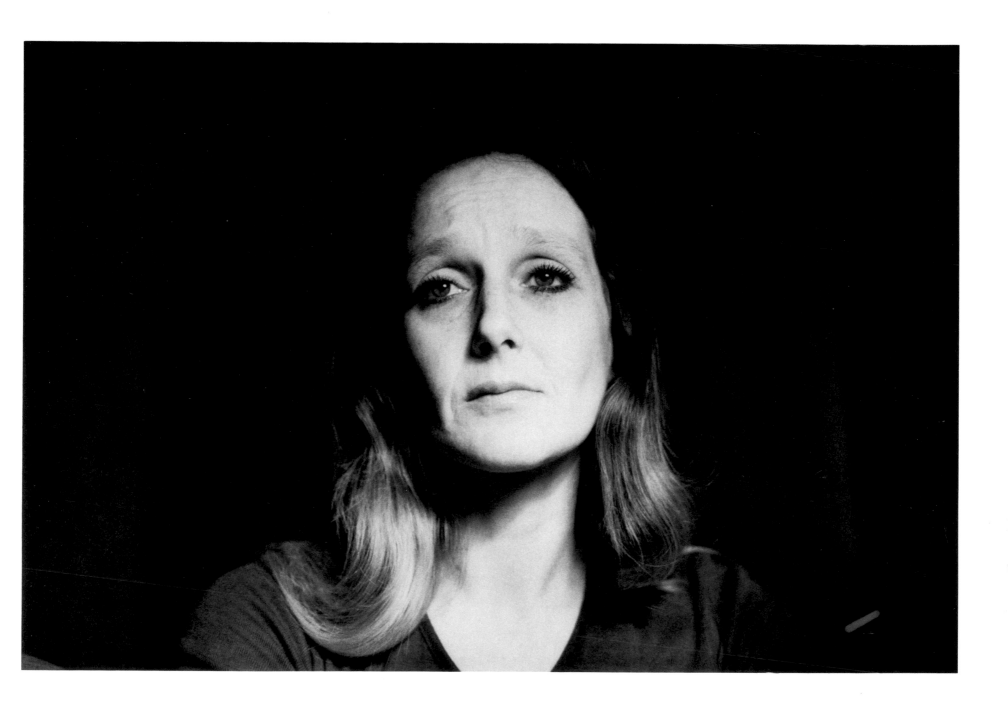

Dearest Kenser, Tininski!
NEVER AGAIN!!! It was enough hell to
last a lifetime. No more "job", no more fix.
FINISHED! What a downer but I'll make
it. Since I made it through this week, I can
make anything. It'll take time but I'm so
grateful. I want to live now. Let's talk.
Every other day I get my "don" (metha-
done, ed.) but didn't touch it yesterday and
only a drop today, despite heavy withdraw-
al crazies. It'll work, it has to. Today too,
only 6 "dons". Well let's get in touch.

Love Beth

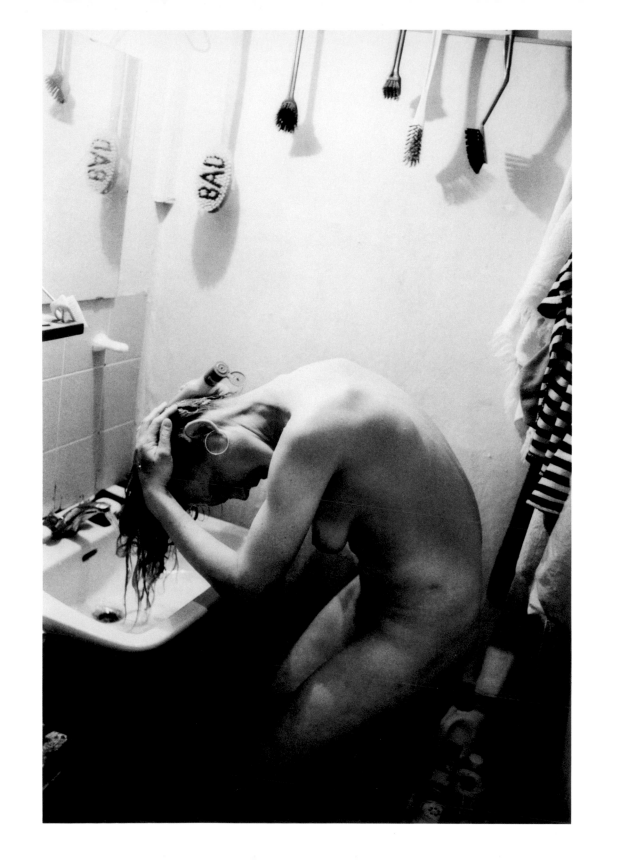

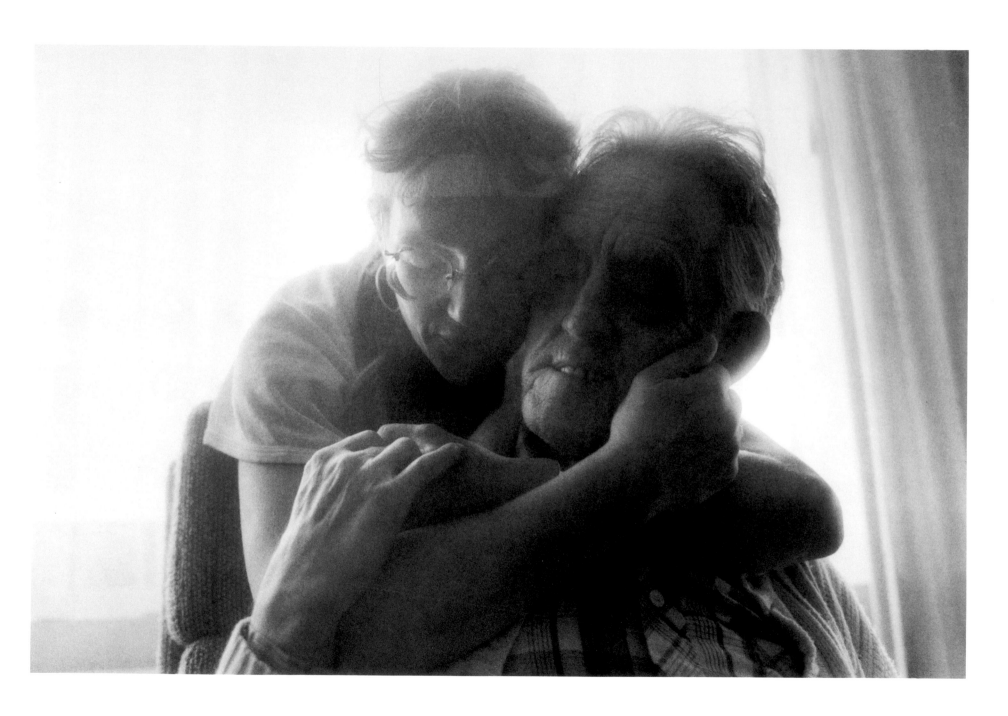

Beth visiting her father

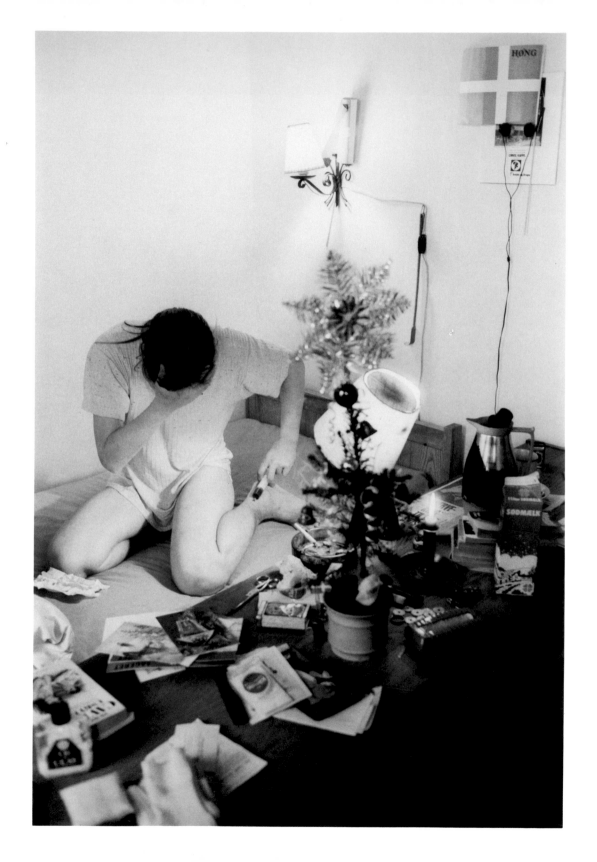

Christmas

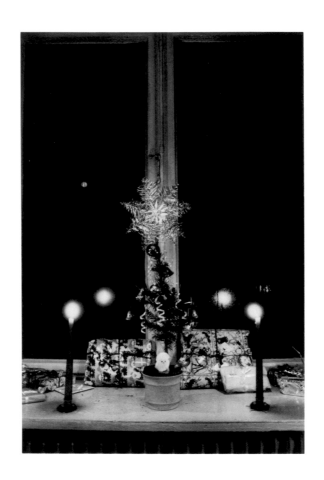

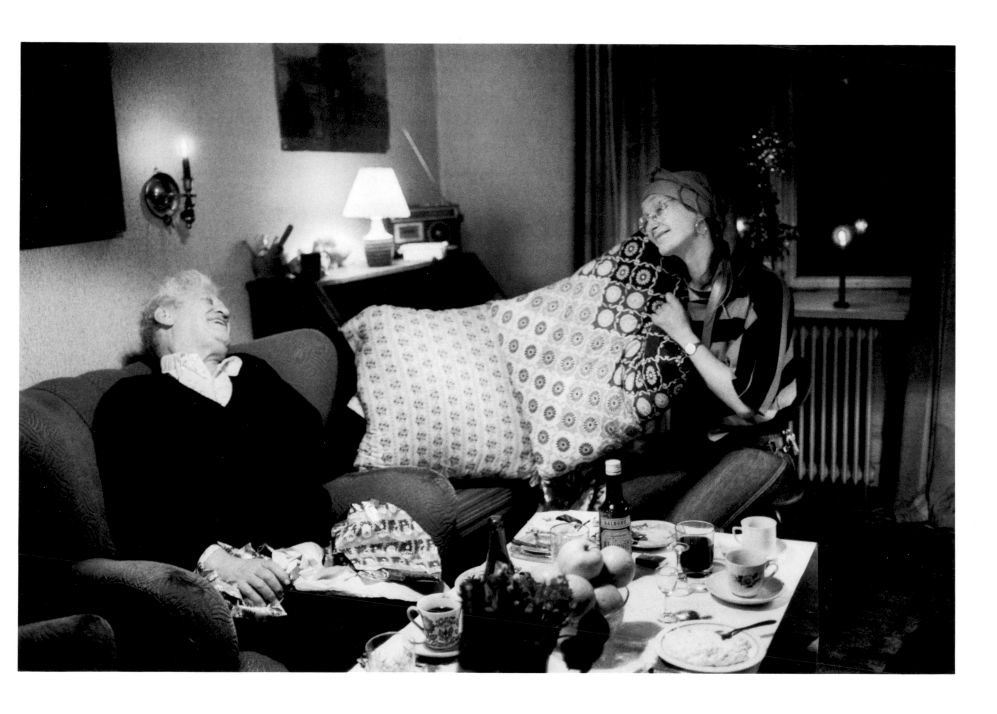

Christmas Eve at Alfred's

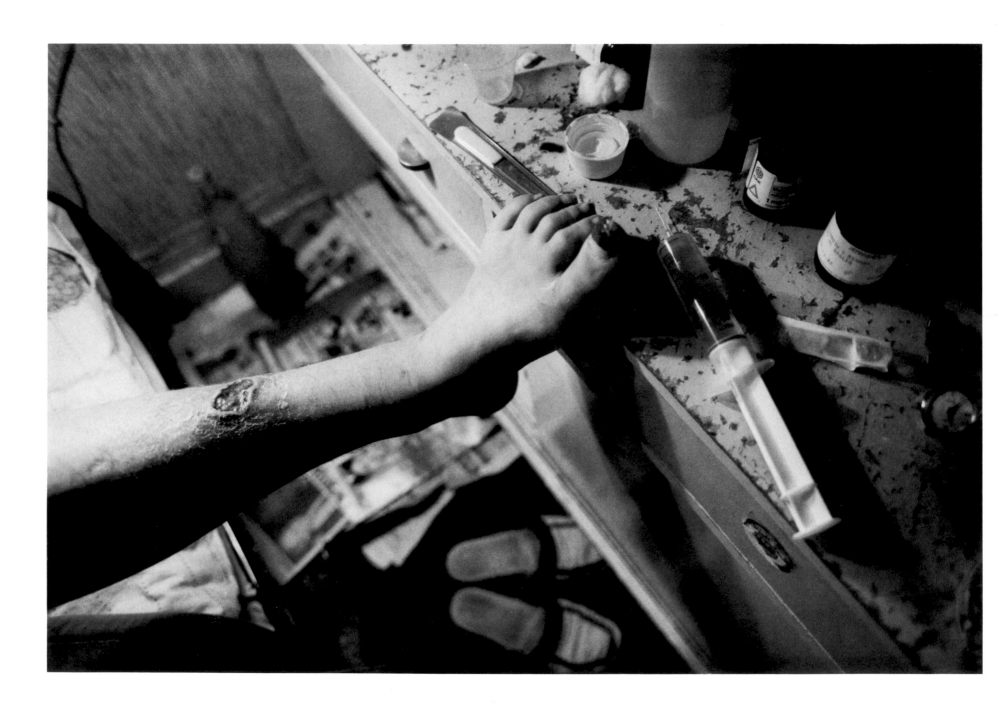

Sores after a fix missing the vein

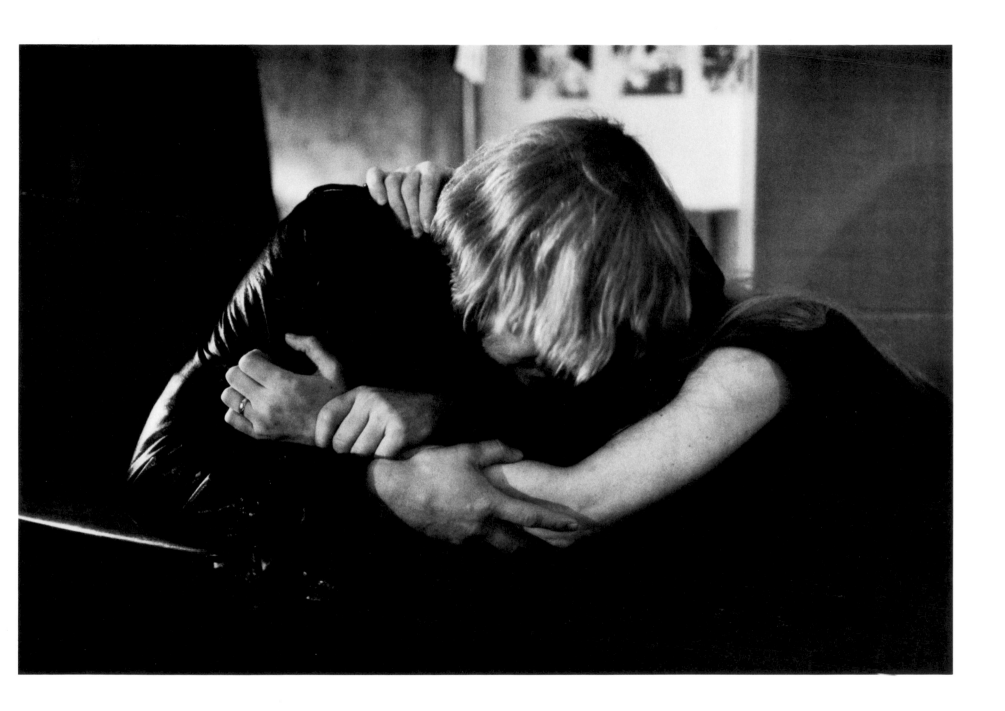

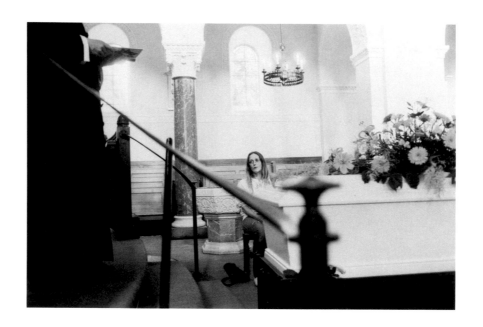

Basse's burial

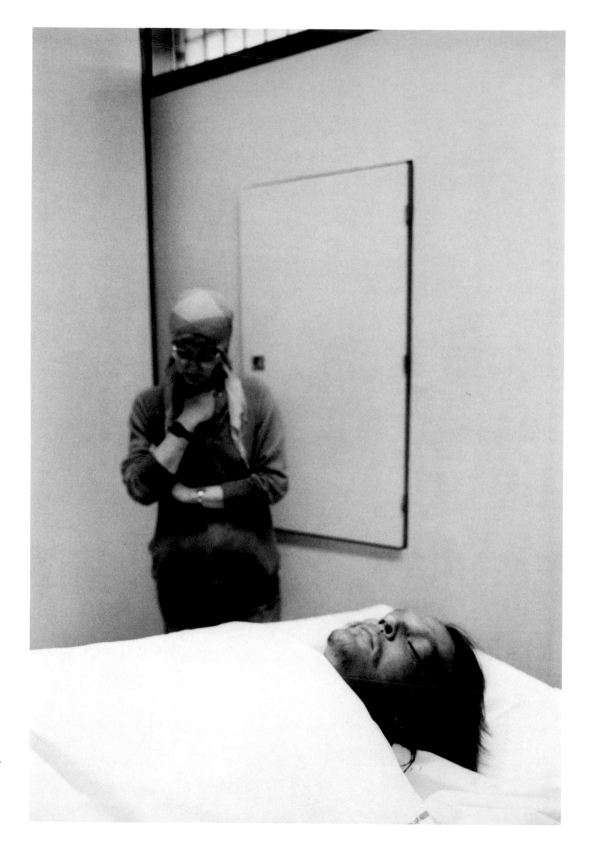

Beth identifying her brother Basse
...dead from an overdose

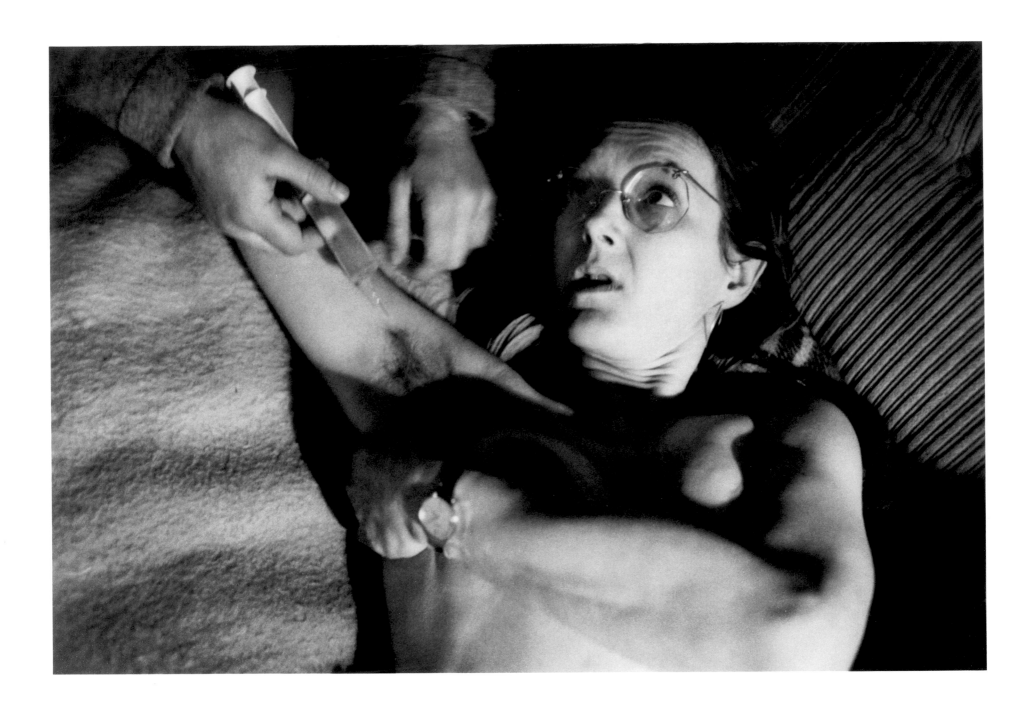

Shooting in a vein she can't reach herself

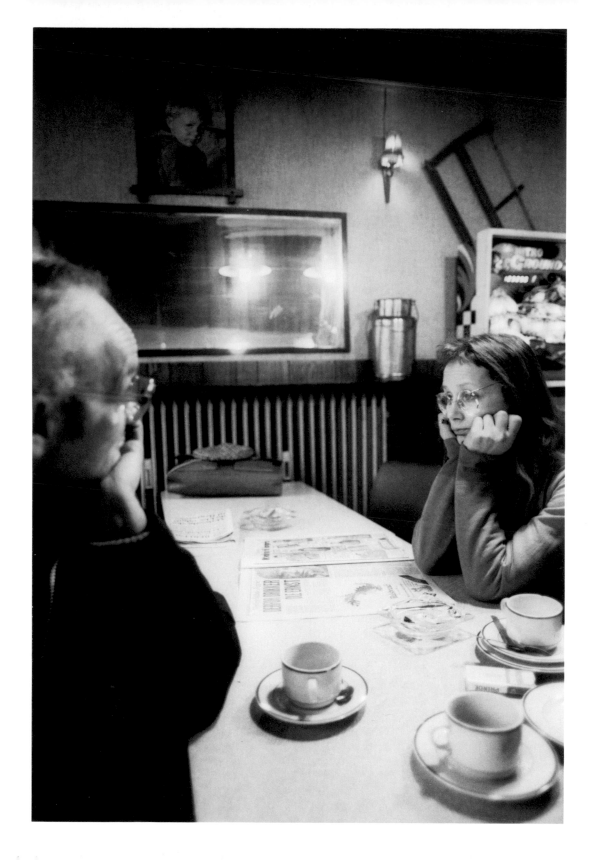

Café Santos

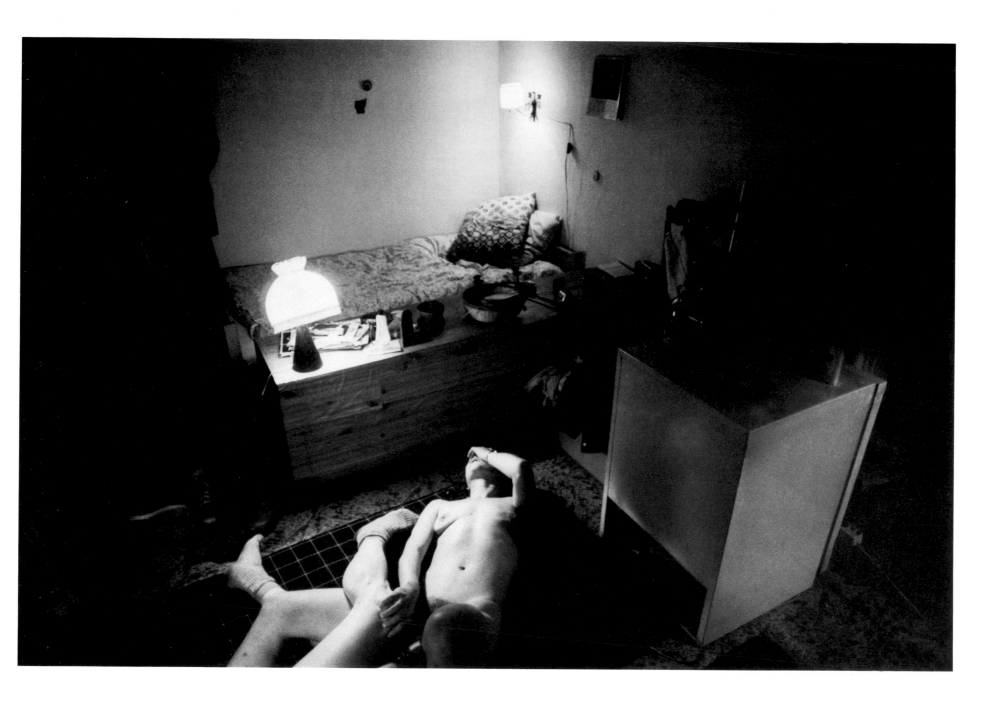

With a John

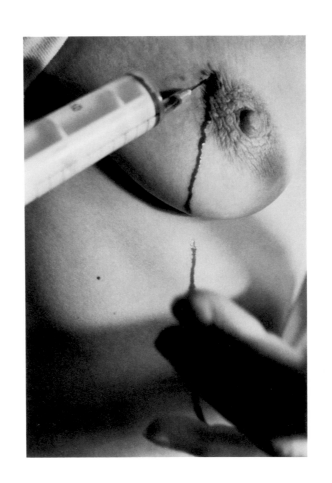

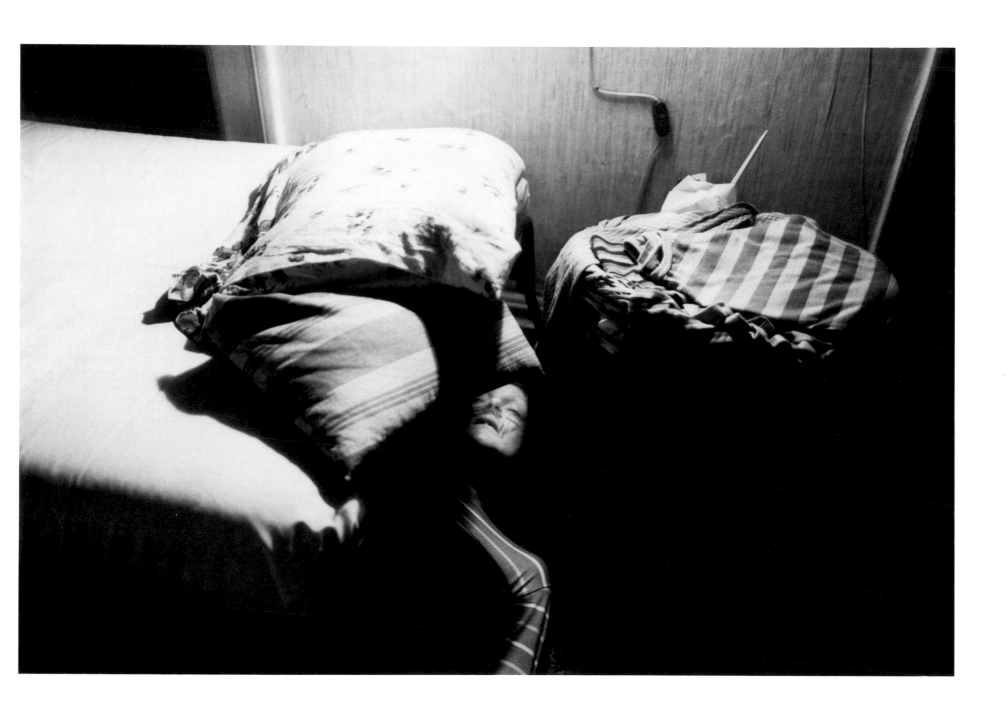

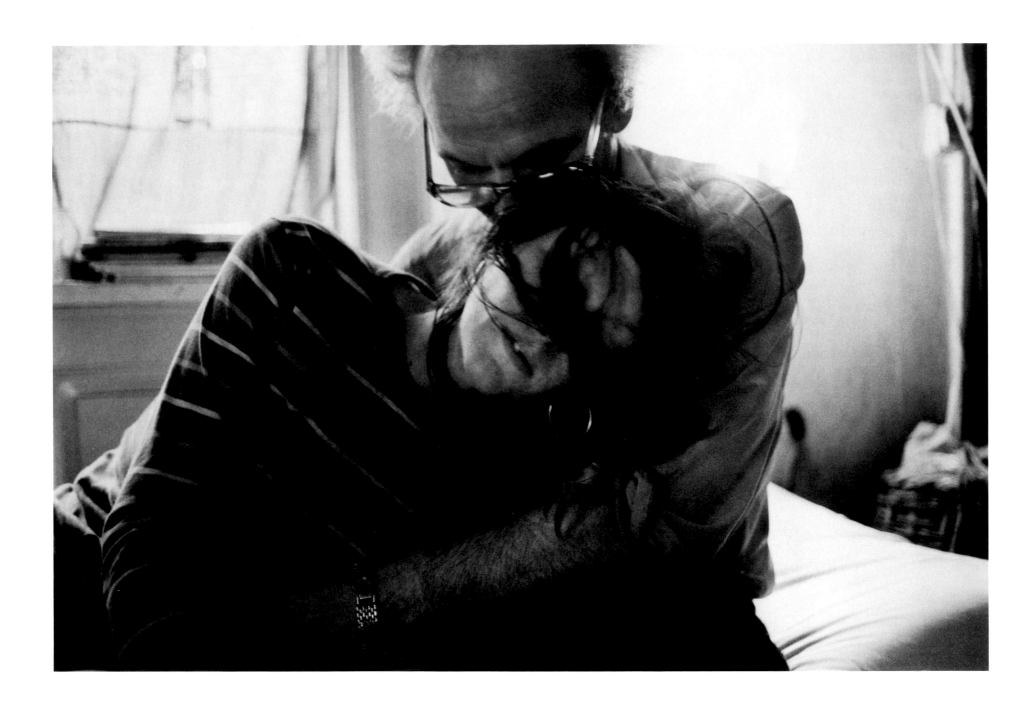

Poul helping Beth

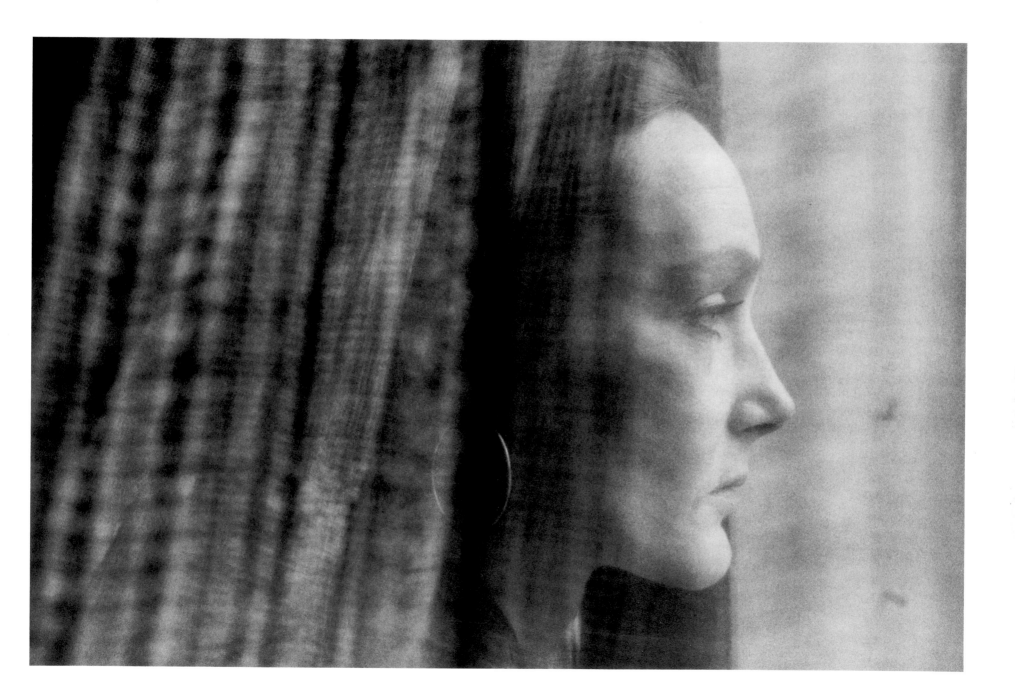

My fathers' birthday. Wednesday the 18/7 -84

Dear Jørn and Kent!
As you probably can see from "the out-
side" I have started to clean my room. It's
great to get going but bad to be stopped in
the middle. But... I have just received "a
very fine visit" by "the forces of law and
order" (not totally unexpected) and believe
this... They wanted to invite me for a cup
of coffee—O.K.! Free coffee, it's just to
grab my clothes and go along. Jørn/Kent!! I
think I can talk my way out of the ten days
I have to sit, that means I get out after I
have talked to the chief of police and
thrown a "little bit of pity" directly into his
human heart. After my plan I will be home
already this evening. J+K!! Write me a
note and give it to Poul. But I'm almost
sure that I will be home tonight then I'll go
directly to work, come and see me tomor-
row, after lunch (13–18).

Well! My "friends" are getting quite
impatient, I better get going. Hope to see
you tomorrow.

Love Beth

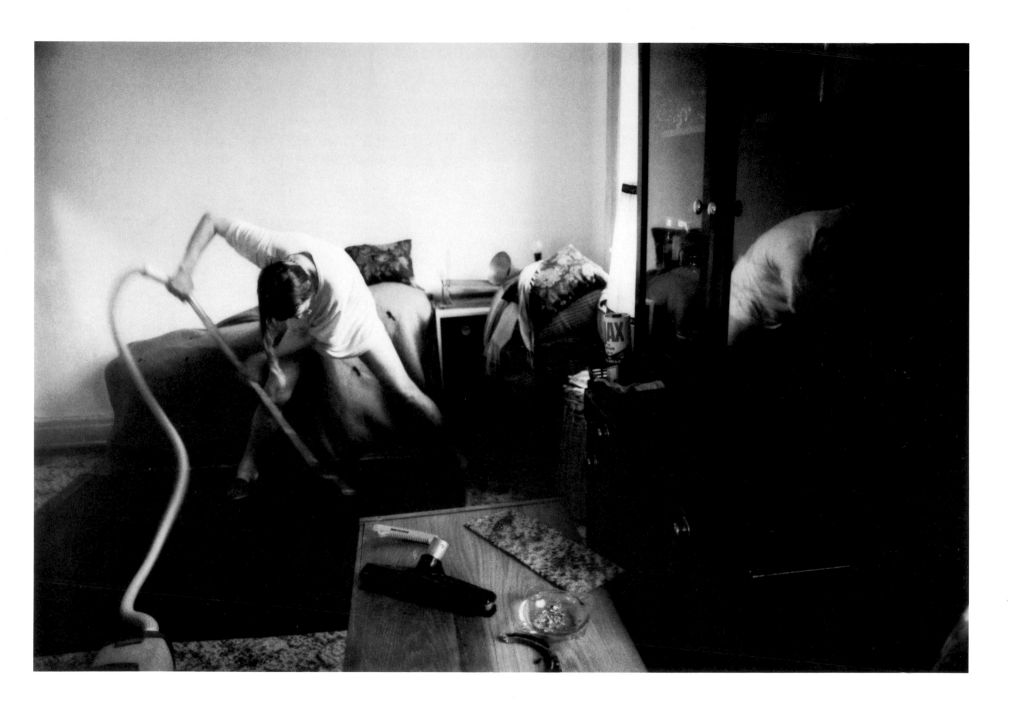

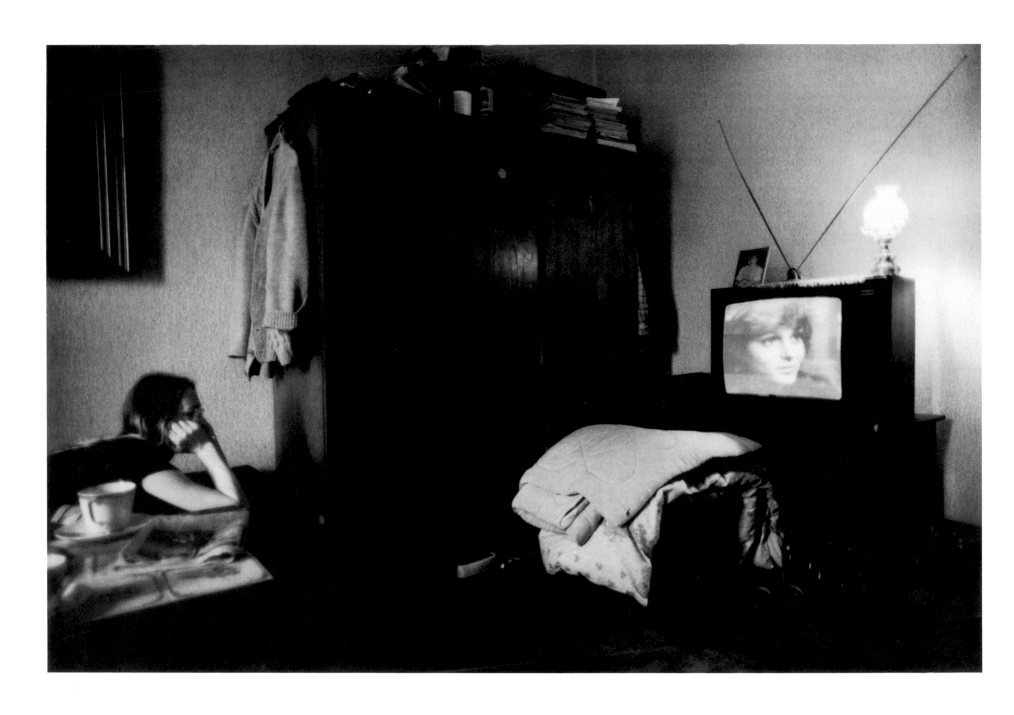

Watching TV at Alfred's

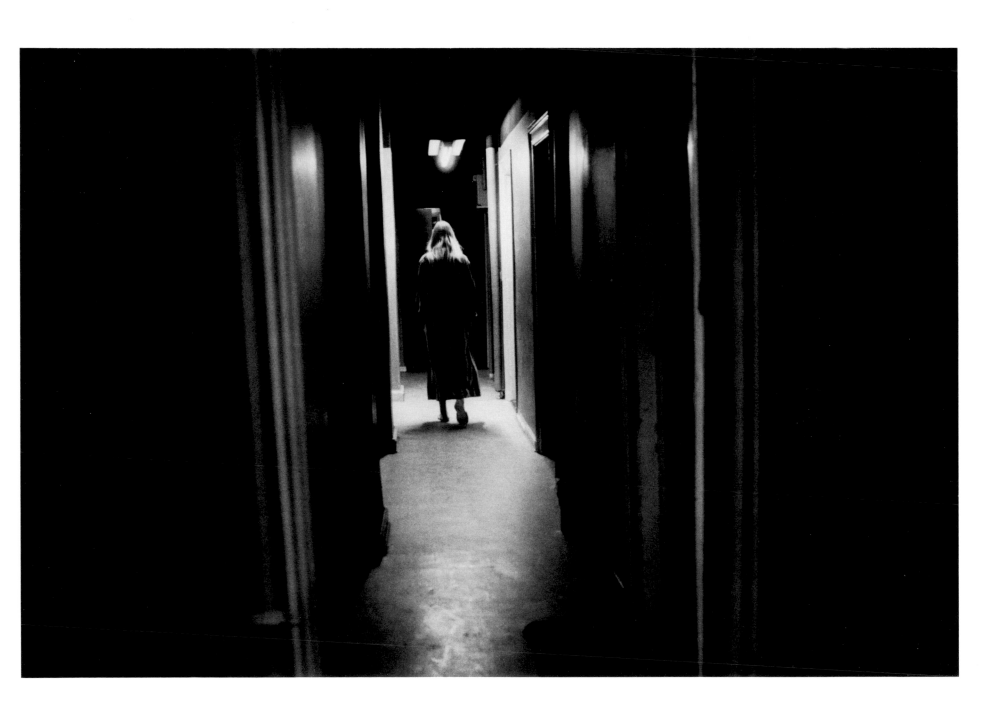

	FINSEN'S INSTITUTE AND RADIUM STATION	
Report number: 28693	Out-Ward for Children COASTAL HOSPITAL IN REFSNÆS Ward for non-tubercular children	

Surname: R.	First Name: Lisbeth	Insurance number: Home address: City: Hospital Insurance Office:
Born: 22/4 1949 in Copenhagen	Age at first reference: 4 years old	

Referral: Referred: a 4-year-old by the family's doctor with diagnosis: involuntary urination, day and night.

During the first meeting, the mother said: "She's impossible, impossible to control."

An objective examination of the organs shows nothing abnormal. She is physically and emotionally normally developed for her age group.

The following meeting shows that the family's living conditions are miserable. They live in a shelter for the homeless and both parents are unskilled, both from institutions as children and have lived a chaotic existence. Lisbeth is the 3rd child of 4. The mother applied for an abortion through Mødrehjælpen (aid for mothers, ed.) but wasn't approved. When the patient was nearly two years old, the mother became pregnant again, again applied for an abortion and again was rejected. She plans to be sterilized.

VC (Vagn Christensen)

30/9–53

The most significant thing is that the patient wants to remain a child. She says so herself. Difficult around the clock. Changeable. Peri-

odically she is nice but when she becomes afraid, angry or stubborn, she pees in her pants. Bites her nails. Has violent emotional outbursts. Treatment has not been satisfactory.

VC

21/11–53

Description: 4-year-old girl. She has a compelling need for a place to live. Six months in an institution for children after birth because the parents were homeless. At 2 or 3 got bronchitis (miserable living conditions), hospitalized and then rehabilitation. On return home, younger brother there and since then she's been very difficult. When asked to explain her behavior, she simply says: I want to be little. Understandable reaction from the child, as she's never had the chance to be a child for her mother. Mother seems sensible enough, very lively and worn down. She's had difficulties tackling this problem. The patient, however, has encountered a great deal of corrections and punishment.

We must admit at this point a feeling of complete powerlessness. To bring up suggestions such as love, understanding, or

tolerance with this mother would be superfluous. Examination and possible treatment by a psychologist is out of the question for the mother because of the other children in her care. (Can probably be of no avail in this case anyhow.) One possibility is to institutionalize the patient, but it seems that earlier periods at institutions have been the cause of her difficulties and the reason for jealousy towards her siblings. I am of the opinion, therefore, that another institutionalization should be the last resort.

VC

27/4–54

Nurse's Statements

Re-admission to Refsnæs.

Alert, lively and daring — quick on the draw with words. A bundle of energy, tricks and ideas. Aggressive and dominating towards the other children. All over the place, especially where last expected. Starved for love — and wraps the entire staff around her finger.

MF (Mary Festersen)

6/6–54

Generally unchanged, perhaps fits in a bit

better, continually sucks thumb.

MF

1/8–54

Of late once again more aggressive and restless. Destroys willfully everything she touches — not only minor items. For example, if she notices a pair of glasses, she grabs them and snaps them in two. Takes everything in the ward. Perhaps we adults have failed her to some degree.

MF

6/8–54

Because of her increasing restlessness and total confusion, attempts have been made to make her the center of things again by giving her presents — sent from Santa Claus — to which she comments immediately: "This is from Dad, it's from Mother, this one's from Auntie, this one's from my brother, etc."

In a similar vein, she gets a card from the staff signed "two friends", to which she shouts with joy, "There are three, my brother too." Nothing can change how very much thought she concentrates upon those at home. All the excitement caused Lisbeth to believe that she's held an extra birthday, the second one here with us: "I was five, then I turned six, and I'm seven now, so I'm ready to start school."

Darling, charming but fresh Lisbeth gives all of us problems. Perhaps if her family cannot have her it might be a good idea for her to be 8 days with Dr. Heinild in his own cottage. But I believe that despite the best of intentions we are unable to give her what she needs most.

MF

15/8–54

Everyone in the ward feels that Lisbeth has been less devilish and somewhat less of an instigator during the last 6 to 8 days. A package from home, (the supply room wrote for some underwear). Lisbeth was joyous: her family in fact asked forgiveness for the long pause. Lisbeth is *no longer neglected.*

MF

7/9–54

A talk with two young parents about a two-room apartment and their four children on an income from the welfare office of 91 crowns weekly. He has been out sick a number of times because of his slipped disc. When he really goes all out, an unskilled working man can earn 161 crowns a week. The rent is 43 crowns a month. I talked for quite a while with these truly nice parents, open and honest, although the mother seems a bit tough in the beginning and although the father, institutional child as he is for three years, illustrates the first sign of giving up socially by saying, "Lots of people live a lot worse than we do." The other symptom of the fact that life is getting him down is surely his slipped disc, which one often gets psychosomatically in such cases. Is that saying too much?

As was indicated on 21/11 1953, it is a bit difficult to talk to this mother about love, understanding and tolerance, but on the other hand, I can't stop giving the parents the hope that it is precisely that which parents call stubbornness and which we call ego or independence which will allow this child a chance to create a decent existence in life. It's a case of parents in our Western civilization believing that they can control the will and the independence of a ball of activity through punishment and beatings (even though I willingly admitted to the parents that that must be impossible given the circumstances). If we can get the parents to understand just a bit of this then I truly believe that everything will work out.

In addition, I talked a lot to the parents about the fact that they should write to their child at Refsnæs. In fact, they don't because the father experienced during his time as an institutionalized child that he was a nervous wreck for 14 days after his parents had visited him every third month. One tries now to explain to him as well as one can that this is different, and that the parents by visiting (one must admit that they don't have the money for many visits), by their cards and letters will teach the child that she hasn't been forgotten, that the folks at home still think of her, and that she has been sent to the country with the parents' permission. In fact we were somewhat successful in teaching the parents this idea.

The best sort of help we can offer the parents at the moment is surely that we suggest that they themselves decide the length of the stay. They may take the child home after a visit on Sunday or whenever they want, or they can let her stay at Refsnæs for a number of months if they feel that it's in the best interests of the family.

The above parent consultation is copied and sent to the child protection agency. The text:

In a case such as this in which relatively young parents are up to their ears in problems and in which one can more than catch a glimpse of the next ten years' total social decay, I believe that society should use all the power it has at its command to help out. Not just practically would it be important to get a

new apartment and I believe I can guarantee that these truly fine people will take it as an extended hand from society and make a giant effort to improve their future situation. These are good solid people and so is the child, whom we have gotten to know. They shouldn't be allowed to hit rock bottom. Can Child Maintenance in Copenhagen do anything?

SH (Svend Heinild)

15/9–54

The whole family visited last Sunday, a total of seven. Lisbeth was so happy and the parents were too. They prefer that we keep the child until the father's sick leave is over.

MF

28/10–54

The file sent to the Royal Hospital's child psychological ward with the question of a possible admission.

SH/BN

23/11–54

Withdrawal description.

During her stay she has proven to be an incredibly restless, nervous, fresh but very charming little girl, aggressive, dominating, full of gags and energy. She needs a lot of attention and sticks to the adults, and one has the impression that she is very insecure about her own home. One would prefer to have the impression of a great deal of concern for her from her home but letters are a rare thing. It is our impression that these two very young parents have in fact reached a point where they feel powerless, and as long as society is unable to help them pull themselves up, one can only give a very dour prognosis.

Withdrawal from Refsnæs
Ott/BN

11/12–54

Child Protection Agency's file 480 grams has been sent for examination. From this case's many entries it is clear that this mother has never been able to accept this child, has never really liked her, a fact that warden Helvig Schultz has repeatedly noted. It is also clear from the files that the family was in an emergency situation at the time that the child was born without the background to this emergency being exposed. They had at that point two children, and the mother tried unsuccessfully to get an abortion. From the child protection agency's discussion minutes from 20/12/1949, that is, 3/4 of a year after Lisbeth's birth is the following enclosed:

Met the father, who stated that his wife is sick. He stated that he has no way of keeping and supporting the children. He has no future and agrees that the agency should take over as ward and parental role as long as this is the case. He tosses out a remark that if the children leave, the marriage will be on the rocks.

Through the years it appears as if it hasn't been possible to give the family any genuine help besides supervision, and that Lisbeth has developed — one can almost say in the classical manner — as a rejected child will develop: With extreme opposition to those who reject her and she can be called, likewise in the classical fashion, defiant, fresh, teasing, etc. Her greatest weapon it seems is her enuresis, which she practices without inhibitions all day and night.

Those who have gotten to know the family a bit better have usually nothing but kind words for this mother and father: many times they have been described as friendly and well-meaning, but they cannot cope with their existence, and the chances from their "pulling themselves up" from where they are in a dwelling for the homeless with four kids, unemployed, sickness, medical payments due, etc. seems nearly zero.

It appears that we have not seen certain documents which show that Mrs. R has been previously married in 1944. During the years from 1943 to 1946, Mrs. R was observed by the Ward Society as she got into trouble with the police on numerous occasions due to theft. In addition, told to take regular checks because of syphilis but she didn't show up. During the years between 1943 and 1949 it appears that she lived a very unpredictable existence. Among other things is the fact that she moved 24 times during this period. Her former cohabitant and later husband, B.R., who was earlier described as a man who had been institutionalized as a child, was given a jail sentence as a youngster. The entire first part of this case (weighing all of 480 grams) is a record of the parents' unsuccessful attempts at finding a place to live, unsuccessful until finding the present shelter.

It is to their unmistakable credit that this family seems to have come along, given their afore-mentioned background.

SH

20/12–54

Conversation with the father, currently on sick leave after hospitalization for slipped disc. Before that he worked in a glass factory but learned in the hospital, that he should find something easier. His bitter response was, "That's easier to say than to do." Weekly welfare payments: 84 crowns a week and rent paid for. In addition, 40 öre daily in sick

leave. Home life seems dismal, although the father, to his credit, says, optimistically, "Everything's just fine", when I repeatedly ask about the other three children. His comment on Lisbeth is, "She seems free", which is probably his way of commenting on her enlarged vocabulary: "Stupid ass" was what she recently called the woman upstairs and which resulted in that family (all of this is going on in the shelter) cursing the patient's mother about what the two of them "thought they were". Later in the conversation it became clear that the mother is usually in tears at the end of the day due to the tremendous burden of caring for four children in the questionable conditions — with one of them, Lisbeth, constantly peeing in her pants. The father has tried to spare 10 öre a day each day Lisbeth doesn't wet her panties. It seems he does this out of love for the child and has helped bring about two "dry days".

About the father: His own mother died right after he was born, so he was placed for the first three years in an orphanage in Ringe. Then he returned to his father, who had married again. He was there until he started school, then he was moved to the home of the parents of his stepmother, where he indicated he was happy. But not so well that his stepmother "found him impossible", so he was placed in an orphanage called Betlehjem from the age of nine to the age of twelve. He hated it so much there that even though we have been talking calmly for half an hour, with this comment he starts to raise his voice and say "I despise all institutions". He also had what he calls "water injuries", and what he got for it right away in the mornings was a smack. When he was twelve years old, he went to visit his father, who was in the interim divorced, and he stayed there during his final year at school, where he moreover went to a new school, Nansen Street. The father drank heavily at that point ("but still one likes him anyhow"), then he became a sailor, "and I was very stubborn and I got beaten up a lot. I had in truth deserved it and it helped."

Well then, but the father preferred not to have Lisbeth at the special kindergarten at the Royal Hospital's child psychiatrical ward: again he repeats that he despises institutions. He would prefer on the other hand to have her placed in the brand-new parish kindergarten on Fredriksgård Street. I try to explain to him that the Royal's kindergarten is in fact not an institution as he imagines it, but one understands — and he says so himself — that he now thinks that his child should have the experience of a normal kindergarten just like other kids and therefore he prefers that we go along with him in this. Of course we agree to this. Incidentally, he likes the fact that we don't have regular visiting hours at Refsnæs, "because then I know that it's all done right, the kids get their noses blown and all of that."

Toward the end the father asks me politely whether I can help him get another apartment, "one that doesn't cost too much".

SH

17/9–55

Readmission to Refsnæs.
Accompanied here by an unknown man who simply delivers her without comment and leaves before the warden or a doctor contacts him. Lisbeth herself says that it was one of their guests. She herself won't say anything about why her parents haven't brought her.

Ott/KM

Conversation with Lisbeth
"Dad's gotten a hot-dog stand, just a couple of days ago, last Sunday."

"All of us have been given a washing at the hospital and we got oil all over, except in our faces 'cause that hurts. Then we were all washed once more."

"Mother doesn't work, she takes care of my brother."

"Mother wouldn't dare hit me when Dad's home 'cause he'd yell at her. But he doesn't yell at me."

"I'm gonna get a package on Saturday." Nothing arrived.

MF/KM

20/9–55

Nurse's Statements
Enter... Lisbeth. Seemed tense and tight at her admission. Luckily she quickly started to relax. A bit fresh, the girl, but generally no problems. She's still got a bag of tricks in her and that leads to some teasing from her roommates.

MF

2/10–55

Like last time: talkative, biting and fresh, aggressive and irritating. In addition, Lisbeth has an exceptionally wonderful way of ruining everything between heaven and earth, whether it be her pals', the ward's or her own things. She can drive me crazy with the same efficiency that she can twist me around her little finger.

MF

17/12/55

The father shows up. He's doing quite well right now, he has his hot-dog stand at the

corner of Hulgård Street and Fredrikssund Street, and he makes about 200 crowns from this weekly with a workday which runs from noon to at least midnight. Money matters are therefore better than they usually are. But the bills are large, among other things they owe another 1,800 crowns in payments on their furniture which in fact only cost 1,500 crowns. But then they weren't able to pay, so a lawyer entered the picture and they accepted an agreement which meant that they'd add 300 crowns to the amount they were down to, they had paid 1,500 crowns at that point. But now the regular monthly payments are lower.

I am still impressed by this man, who is going strong now; he works hard and honestly and he truly is fond of his child and is completely sincere when he says that he wants her home by Christmas. And he knows what he is talking about when he says this because he is a child of institutions himself and never was allowed to come home. But it permeates the air and the father doesn't attempt to hide the fact, even starts to talk about it on his own, that it's the mother who can't stand Lisbeth, among other items, she's demanded that if Lisbeth returns, she wants a coat of the same type as her older sister Ida, who just got it in Messen's for 90 crowns.

Here is an example of how direct economic aid would be exceedingly worthwhile. Therefore we should give this family a total of about 200 crowns at Christmas, probably the Master Carpenter Holm's scholarship. I've already mentioned it to the father that that's what will happen.

The mother is depressed all the time from living in the tenement, according to the father, but until now they haven't been able to move because they've had to pinch pennies to pay the 45 crowns a month... "and then you can't just say that you want something else which is more expensive."

SH

27/12–55

Withdrawal description

We haven't in any case had any sort of contacts with the parents, just as in earlier instances; they don't visit the child during her time here and only have sent her a single package or greetings or so. In the beginning of December she got a letter from home in which the father wrote to her that he'd like her home at Christmas. This news is something that brings her to such a state of excitement and joyful expectation that we think it's best to hold her father to his word and give her leave before Christmas.

OH/KM

24/6–56

The nurse's observations

Readmission

Generally as described earlier:

Nervous, restless, continually fresh, pushy, needing contact — almost sticking to you. Ants in her pants all day long, all over the place. Fights with her sister most of the time. Usually pulls everything to bits, everything she can get her hands on. That undefinable charming and endlessly touching about Lisbeth during her earlier admissions which one couldn't resist (despite what she did) is nearly gone behind her tough and calculating exterior.

MF

23/7–56

Although Lisbeth is a thorn in the side of the ward, it's gotten better than we expected at first. Things improved after Lisbeth and Ida were seperated. Constantly and seriously bites nails, picks toes.

There's still something left of Lisbeth's true self, although it's difficult to reach it. There are many minuses but there are also pluses. I'll come back, Lisbeth promises.

MF

27/7–56

The mother was furious with Lisbeth, who had torn off the new wallpaper in the bedroom, among other things. "That kid drives me crazy. If I start to hit her, I'll beat her to death." The mother added, however, that she mustn't be sent away — something which she was aware of at the time of the most recent admission here. Miss F. says that it would be advantageous if the father would transfer some of his love for Lisbeth to the mother: Lisbeth causes tension between them. The father seems to understand Lisbeth better than the mother does. Conclusion: A "troubled home" with childcare problems: must be helped. We've gotten these children free childcare for six weeks.

SH

24/8–56

Mr. R. shows up. Lots of problems right now, fights with the people upstairs, his wife cries at night when her husband returns at two in the morning from working at his hot-dog stand. She can't take the housing any longer. But the situation doesn't look promising at the moment. Working conditions in that company he worked and sold hot-dogs for earlier were dreadful. Therefore he's decided that he wants to have his own stand. He's applied, gotten permission from the authorities, from the police etc. "But the official

papers haven't come yet." In other words, he's out of a job since last Saturday and it's difficult to pay the "regular bills", which come to about 45 crowns in payments on a loan of about 1,300 to 1,400 crowns, which they still have on their furniture, plus 200 crowns for their own clothes. Added to this is a plumbing bill of 230 crowns which he has to go to court about next week. The new hot-dog stand costs 1,800 to 1,900 crowns, which of course he doesn't have to pay right away, and which he had said, when he was at Dan-hof's and they wanted 400 to 500 crowns. "They're not looking at a Rockefeller." It's true, there's still a drop of humor left in him and also such fine sense of what's what that he can see it would be a catastrophe for the family economy if they got a new apartment right now. They pay 44 crowns 99 öre in rent now and one can hardly imagine that a move to something better would cost anywhere under 100 crowns a month, but that would spell economical disaster.

But his wife's put pressure on him; as mentioned she can't stand living where they do, he's out of a job, the only certain fact for the moment is the meeting in court with the plumber next week. So his only source of hope in life right now is just to get his own hot-dog stand, to become an independent hot-dog man and not be dependent upon others' whims.

We have to see if we can get him a little money from Holm's scholarship from Refs-næs; cash is the only cure which will give them a helping hand right now.

We'll get the family 250 crowns from the scholarship.

It occurs to me that it would help build up Mrs. R's self-image and belief in life if we put the two youngest kids in Refsnæs for a few months and let her resume her job as store assistant for a while so she too can help the family economy. It's obvious that Mrs. R. has been taken down a notch by all of this and has become tough and bitter. The only time during our talk where in fact I got a tiny smile and glow from her was when we discussed the time she worked in the store when she was young; she seems to have been happy working behind the counter. Maybe it would give her a bit of her old self-confidence.

SH

8/2–57

Talk with the father. The parents have visited doctor-in-charge Gudrun Bruun, and it's been decided that Lisbeth should be put into Baunegården from Monday, 11/2.

SH

26/2–57

And we've gotten Mrs. R. a job as a sheller at Alfred Benson's Inc. from the 19th of February, but after only three days she quit; her eyesight was probably too poor for her to keep up and get the shelling right. We are working now in the office on getting her something else.

The other three kids were already on the 20th of February placed in Refsnæs in order to give the mother a chance to work. I drove there myself and they were happy as they were about to go for a walk in the woods.

It's still tough trying to get Mr. R. a new stand.

SH

19/3–57

I drive to visit the family and what I had dreaded was in fact the case, as both Mr and Mrs R. are at home in the middle of the afternoon. In fact I've driven past Mr R's stand area at Tomsgård Street a few times recently and found nobody there. Mr. R. is upset and states, "Nothing can make any difference." He's depressed now because he doesn't have the money to buy his hot-dogs, which cost 42 crowns, he owes those from last week. Likewise he owes the baker 27 crowns for bread, money he doesn't have either. I give him the last 30 crowns left from the collection mentioned earlier to pay for the bread and thus he has about 45 to 50 left, i.e., now he can buy the goods and get on his feet again, which he then promises to do, encouraged strongly by his wife.

Mrs. R. couldn't take being at the Society for the Disabled, "because when we were about to eat lunch it turned out that the man across the table had no legs. I had to go out to the toilet and throw up." And the job agreed upon with the landmines was something she didn't feel she could do. She gave it a try but made lots of mistakes "and when it only gave 0,7 öre each, you couldn't make too many mistakes." I told her that she should try those two places because both of them will try to get her a job. Meanwhile, she'll try to get something in a private company but this will certainly be doomed to failure.

SH

17/6–57

Mr. R. calls: he's miserable and depressed. "It's a mess." Last week he had to throw 61 crowns worth of hot-dogs out; they'd gone bad. He owes for two weeks now and can hardly get a hold of more. His wife has been out of a job since the Whitsun holiday. She chose a cleaning job although we recom-

mended a number of other things and now there doesn't seem to be any more cleaning work. There isn't a cent now and they don't know what to do. I don't either: more and more I feel that this kind of family can't seem to find its niche. In between one and three months the three kids come back from Refsnæs and we feel we haven't gone beyond the stage when we sent them away to give the family a breather and allow them to get on their feet again. Right now I am not able to think of any solution other then getting Mr. R. to the central job office, possibly the division for job handicapped and I'll send a copy of this entry to prepare his application to either Job Aid Svend Krumbak or the Head Clerk Regin, whom I've talked to about this case.

Mr. R. will now be satisfied if he can help out at a hot-dog stand, get some form of salary. Isn't there anything we can do?

SH

22/6–57

Mr. R. got a job working at the Geodætisk Institut as a helper and starts the day after tomorrow, 24/6.

True the results of the last six months' work with this case are clear — not good. We are back where we started: the family still can't care for itself, the hot-dog stand hasn't worked out, removing the three children from the home for six months hasn't been a success — as the eleven-year-old has tried to leave and because the family's budget doesn't function through jobs on the part of both parents, which was the aim with the childrens admission to Refsnæs. Welfare office problems exist: taxes, rent, furniture payments are still too much for them. But it's

thought-provoking that the hierarchy in the bureaucracy of society still invests over 100 crowns each day on this family for the care of the four children. These arrangements are not helping any of them.

SH

30/11–57

Irgens Möller, the leader of the orphanage calls and says the he really doesn't know what to do with Lisbeth. Basically everything is O.K. and she's developing "although she gets somewhat confused every time she's been home." Baunegården is of course a home for the city of Copenhagen, a very expensive home. One can't expect to have a child there for more than a year or two, so within six months he must decide what to do with Lisbeth. He doesn't think the family will accept her placement at a regular orphanage and doesn't think a private home will work as the family will probably want to get her exactly whenever they want to. Perhaps a boarding-school placement will be recommended but that's what we have to find out.

SH

11/2–58

Mrs. R. shows up because they want to get an apartment at Klokke Street 9, a two-roomer warmed by a stove. It's not very big but clearly better than what they have and they will be able to get out of the area they hate so much.

SH

21/3–58

Note the enclosed letter from Mayor Urban Hansen to Mrs. Hedvig Schultz of 8/3/58 and her letter to me 18/3/58. The mayor's viewpoint is wrong, in my opinion. The principle in this case is to get the family beyond the "shack area" because this environment is

such a hardship that no other form of aid will succeed in my opinion as long as that problem still exists. Whether or not the family will get back on its feet then is another question and I have my doubts here too. But it's a chance which we relatively cheaply could grab with the help of, let's say, about 500 to 600 crowns a year. Right now we use without hesitation 12,000 crowns a year to keep Lisbeth at the expensive home, "Baunegården". The case is viewed strictly economically from the point of view of the mayor: If the family can't pay their present rent bills then they probably can't afford even higher ones. This point of view is wrong because the case deals not with economical factors but welfare-support ones. *This family needs this kind of treatment* as it's precisely that — that they cannot make it alone, they mess up, this is their disease. And of course we can once again discuss where this disease comes from; in my opinion what is mentioned a number of times earlier in the file is true: that these two very spiritually and physically weak people come from institutions with a terrible start in life and who never really had a genuine chance to get a fair start. One has never really tried to evaluate this family from the point of view of welfare and support but instead only from the point of view of whether they could make it on their own or not — which is what they are unable to do in our open society as it is today.

SH

17/4–58

Mr. R. calls and say's they've gotten a new apartment at Klokke Street 9, first floor. Two rooms "with toilet and sink" that costs 66 crowns a month. He's happy and his wife

even moreso, "cause it's a real house of stone." They'll move around the first of May.

He's still working at the Geodætisk Institut but must leave September first. He's looked for a job at the nearby Proviantgården and hopes to get one. At the moment his wife does cleaning at Bahn's Hotel from 8 to 3 p.m. for three crowns an hour. He says it's tough for her with her poor eyesight and she has just gone to the Royal Hospital's eye clinic where they sent her for an examination at Ward H because she's got a lingering case of genital syphilis. It's something she takes offence about.

SH

28/10–58

We've received a letter from the visiting warden, Mrs Hedvig Schultz, from 25/10/58 and we have written to Head Clerk Regin at the office for job handicapped the following:

Mr Regin, Managing Officer,
Office for the Partially Handicapped
Nørre Street 49, Copenhagen

I would like to contact you again with reference to the R. family Klokke Street 9, Copenhagen N.V. The reason: *Mr. R. needs and must be given a reasonable job.*

The motive for these extensive queries and with all our considerable efforts is that we in the clinic have invested a great deal in this social experiment, have clearly indicated for those parties involved that this family *must be helped* — and that this case must not ever become just a routine case. If it does, there will be consequences, as we know. We'll see backlash, we know that, if we don't make a success out of this one case, if we can't get things going on the right track for this

family when the world-famous Danish social-welfare system is making a concerted effort.

If we fail, this case will illustrate that our social welfare apparatus in effect falls to pieces in the case of a specific challenge: This family can't make it *themselves;* we all know this fact, but it could be helped to become a family which can function — if only we could coordinate all the various efforts which at this point are involved in the case.

This *must* be made to happen, it's now or never; i.e., Mr. R. must be given a job with a normal (workingman's) salary. If that job doesn't work out, he must be given *another* one with this salary.

Case number 13
The advisors at Child Care in Copenhagen
Copenhagen 25/10–58

10/11–58

After the above request we've gotten Mr. R. a job; see the enclosed letter from the Central Job Office written on 8/11.

SH

16/6–59

And now the television has arrived! I visited them at home because the family has been here but hasn't been able to get hold of me. In their living room, which is fairly nicely furnished (besides the dreadful paintings), Mr. R's on the sofa. He's worked at the job mentioned earlier until now and earned about 225 crowns a week, but now he's suffering from backpains and the doctor believes it's his old slipped disc ailment which is showing up once again, all of which sounds reasonable. A man with such serious difficulties in life can't hold a regular job for very long. We've now sent the admission forms

and await admission in the very near future. So everything's bound to fall apart once more. It's a fact that Mrs. R's got a job right now in the cafeteria in Rich's house; she pulls in 125 crowns weekly irregular working hours, but as mentioned before she cannot see very well and she'll have to give it up in the near future. While we discussed these things, three other kids ran in and out of the living room and out in the area between the houses in this crowded typical working-class area. They look healthy and happy and in no way resemble children of misery. They are trusting too, towards me in any case. But then Mr. R pours his heart out about Lisbeth at a full-time school. She looks great as mentioned earlier, "but they don't teach her anything there and respect is neither taught nor learned. The kids can do what they want and *that's not good at all.*"

Mr. R is developing bitterness and a lot of aggression towards the school, about how much his kids should learn and he feels that it's all so unfair. Mr. R. raises his voice when he mentions these things: that his daughter, Lisbeth hasn't learned to add and subtract as well as the other kids. "And she's now in the 5th grade so there's only three years until she's through with school." "And then what", he says strongly, "Should she start learning then?" It is difficult to explain to him that all that is possible is being done to make this very difficult child fit in, a child who has been given additional problems by a mother who rejected her. One can't really expect to see any real future in all of this. Fortunately, Lisbeth is about to go to summer camp with her school. As mentioned, she looks happy and content. And in the corner there's a love-

ly television on the cabinet, one purchased for about five or six months ago on the installment plan, and they pay 80 crowns a month. That means they still have about 1,000 crowns to pay. The local warden, Mrs. Schultz, who has really helped this family, by chance stops by while I'm visiting. She confides in me that the family debt right now is over 2,000 crowns. "It should be possible to breathe deeply and to pay everyone his due and to have money for their daily needs — not too much or too little". This is one of the sentences I hear Mr. R mention in the course of the conversation and which rings in my ears as I leave through their chipped and vandalised main door with its graffiti and drawings. No hope, no hope, but still! This won't be the last time we'll be in touch with the family.

<div align="right">SH/AD</div>

6/10–59

I make a visit. Both parents are at home because Mr. R. is on sick leave right now; he is treated at Copenhagen's Physiological Clinic and has had blood test and other tests, "they are unable to tell me what's wrong." He feels unable to resume his old job at the Metal Wares Company where, doing piecework, he earned as much as 250 crowns weekly and where they've told him they want him back. But as soon as he bends down, he gets backpains. Mrs. R. has gotten advance benefits from the Disablement Office; if her husband is fully employed there'll be at least 100 crowns a month, if not, there'll be about 400. There's a good deal of optimism despite everything. Both of them express a deep wish to "get a larger apartment", and one must admit that their four kids are squeezed to-

gether in bunk beds in one of the rooms in the apartment. True, they've taken a look at the new apartments, The Doctor's Society has built in Østerbro and they will be so grateful if they get an apartment with a living room and three bedrooms so that there will be room for the whole family. But to what degree can all of this come true? Lisbeth is doing well right now in her school, Stevns Street. Ida is a teenager and has trimmed down her weight. The other two kids play around in the mess outside of the windows.

<div align="right">SH/AD</div>

3/6–60

Admission today to Kyst Hospital at Refsnæs.

Lisbeth is accompanied by Mrs. Schultz, who states that the parents are nearly desperate as far as Lisbeth is concerned and they've recently talked a good deal about having her placed somewhere, but not through the child-care services.

Lisbeth started wearing glasses for reading a while ago but hasn't wanted them here as she "has no desire to go to school here."

<div align="right">GJ/IP</div>

20/6–60

Description: An eleven-year-old girl who has been admitted for vitium domesticum (poor living conditions, irresponsible parents, wandering attention, restlessness, disagreeability, bed-wetting, regression, nail-biting). The real reason for Lisbeth's admission this time is to improve conditions at home until she has to leave for summer camp with her school. She's been restless here and very confused. Does lots of naughty deeds but needs contact and is open and trusting. There is some tension with her pals. Continued enuresis. So-

matically, she's completely healthy.

<div align="right">GJ/IP</div>

12/12–61

A meeting with Mr. and Mrs. R. once more. From the first moment one can tell that things are going better with the family. They appear nourished and dressed well, have an attractive overcoat and cape on, respectively. They resemble a couple somewhat like middleclass types. And they don't have that worn, confused expression on their faces which I've seen so often through the years. Without doubt there's been a social advancement for the family: First of all, there's a new apartment in a much improved section of town. The mother receives 500 crowns a month in disablement. As numerous examples illustrate, she can't stand working. Husband has once again gotten a job as an employee in the hog-dog stand company. And the marriage — which has been rocky and on the verge of breakup before, seems improved. The parents look lovingly at each other and they state:" OK, we have our off moments like all married people, but we've grown up a bit," Mr. R. says. "True, you aren't as wild as before," Mrs. R. comments. But then there's the basic problem: The good ship "R. Family", which as we know has gone through so much during the last eight years, is once more about to sink. We now have a report from B.H. that Nærumgård, which incidentally Lisbeth is fond of and which the parents have faith in, indicates that the school she attends has threatened to expel her for being difficult. She was caught red-handed taking 40 crowns, "smokes a blue streak", and as I mentioned they've threatened to get rid of her. It's quite obvious that if she's thrown out

of that school and thus forced to another institution, it will be a huge blow for this fragile, very sensitive but weak family, a family which has the least going for it one can imagine — but a family which has pulled itself up during recent years.

Doesn't one have the right to say to our social-welfare system in general: That's it, now is the time to prove what you can do and stop moving Lisbeth on every time she annoys someone or other. That would happen in the next school or institution she's moved to. In our 27-page-long case file, we described how this unhappy child from incredibly difficult conditions has been put in if not 100 then ten to twenty different institutions while her home has wobbled on thin ice as a family unit. She's been at boarding school, and at the city's most expensive institution for children: Baunegården for two years, she's been at the child-psychiatry ward of B.B.H., which has the country's best minds in this field, she's had the best possible warden, she's been put at Refsnæs numerous times, she's been put in the best institution imaginable. "My soul, what else do you want? She will in any case in a couple of years take her fate in her own hands and enter adulthood. Who do you think will be there to help if she's forced to switch horses in midstream again?

She must be allowed to remain in the institution and school where she's now placed. She mustn't be made even more insecure while she's still of school age. And one must demand that the school must not give her special treatment, given her difficulties, fresh comments, smoking, beyond what the school itself provides. *What will carry her through these difficulties are personal contacts.* P.S. As Mr. and Mrs. R. are about to leave, she remarks with a huge smile, "And we also got our own telephone. Care for the number?" This is for sure a family on the move. The next item's surely a car.

SH/MH

16/12–61

One more deep sigh here. The leader of Nærumgård, Helmstedt, called and mentioned that they believe strongly in admission to Stuttgården and one understands why as the counseling psychologist believes that a separation from the parents was in fact indicated. As far as the girl's behaviour, it was stated "it was at the very last second that she started to be treated." This is the sentence which evokes the deep sigh. As long as we are unable to understand that it is the girl's family situation which should be treated and not her symptoms of pilfering, restlessness, smoking and sexual curiousity, which in themselves need treatment, then we haven't gotten very far in understanding in our child welfare. Thus we just continue on like the past generations with "organic" medical treatment, diagnosing the symptoms but extremely rarely the whole total picture.

SH/MH

9/3–62

Lisbeth has been admitted at Himmelbjerggård, and the leader Torpe called and everything's O.K., no problems there. We should have placed her there right away. So now that's O.K. so far. Something's bound to happen though once again.

SH

13/9–63

With regard to some other matter, we've got-

ten in touch with the family's faithful warden through the years. Mrs. Hedvig Schultz, and we've told her that we'd really like to know how the family is doing. Mr. R. is doing fine right now, works from 9:30 to about 8 or 9 at night and says he's satisfied. Life at home is probably also O.K. and one can in fact note that Mrs. R. looked great today and isn't the worn-down individual who came to us originally. She's got rosy cheeks, gleam in her eyes, and makes witty although sharp remarks.

The gravest problem as usual is *Lisbeth:* They don't want her at Himmelbjerggård because she's too much of a pilferer, and at the age of 14 has taken part in car thefts, even part of a group totaling a car such that repairs run to "over 3,000 crowns". Therefore she has been discharged but with Child Ward's aid placed at Grindsted's Boarding School, which costs 645 crowns a month but for some strange reason the family has to pay 25 crowns a month; the rest is paid by Child Ward. I wonder why it is done like this. She is said to be doing very well in school and we've brought up the idea of her getting a degree or something if she wants to. On this point Mrs. R. again heads for their precious cupboard and this time brings forth two attractively wrapped files which prove to be from Kehlet's and they contain Ida and Lisbeth's pictures, from the time that they were infants and the standard confirmation pictures with white dresses and all of that. One's sees the shine in Lisbeth's eyes; she'll get by one way or another (what about as the local Christine Keehler?)

The fine apartment here was moved into briefly after Mr. R. had forced his own entrance to see the mayor (this is described

dramatically — how he was first shown out by a policeman "because he didn't have an appointment"). But when the door luckily was opened, Mr. R. jumped in and asked whether or not a citizen could speak to the mayor and it seems that one can. The Town Hall officer looked askance but Mr. R. got a gigantic cigar which he saved for months and finally gave away as he wasn't a cigar-man. (Shame that one didn't come by on one of those days). But Urban Hansen, the Mayor, said that in fact there would be action taken in this case and thus they got the apartment.

This family has reached another level than the one they were on when they contacted the ward ten years ago. It's tough to say if we've aided this development, although that can't be totally out of the question, or whether it's due to the fact that in the last ten years Denmark's become a welfare state with total employment. We'll hear more about Lisbeth in the future.

SH/GO

1/10–63

Mrs. R. called and asked if I would visit them after 8:30 p.m., "as Mr. R. comes home then, you know." She would also invite Mrs. Schultz, who's done so much for this case, so we could talk with Lisbeth about the future.

Lisbeth was at home. She's a big girl, seems mature for her age, only 14 ½. Something unmistakable about her indicates that she's no longer a a child. Dressed in an imitation leopard robe, she was lively and vivacious (it seems she said later that she couldn't stand all of them, that is Mrs. Schultz, her warden, and myself, over every night.) She's glad to be home and doesn't want to be institutionalized any more, no matter where it

is — home economics school, boarding school, whatever this life might present. There was no doubt about that. After all, she's been placed for five to six years in all these famous institutions. And it's understandable that she feels this way, and thought-provoking.

Lisbeth waltzes in and goes to bed, and our discussion continues around the table while the TV is still on. It seems that she's done just about everything: at 14 stolen at least three cars, one a luxury item she drove around in Ålborg without having an accident. Together we wonder how a 14-year-old can do so well when older people find it tough to pass their driver's test. But that's how things are. What she didn't do — and this is the reason she got expelled from the school in Grindsted, is steal the bottle of wine which a few of the girls brought back and drank at the school. One of the others did that. According to her parents — and only them — the school didn't treat her well. She was threatened and even got beaten. Now she wants to enter the job market and her interests include clothes and music. We dwell on the idea of a salesgirl job.

SH

19/11–63

Alas! How long was Adam in Paradise? Today Mr. R. shows up without appointment. He's upset and looks dreadful, hasn't slept because of the fights: "I can't take it any more". "It's too goddamn much." It seems the mother doesn't get along with Lisbeth. "I despise you, go to hell!" she says to her. Even the other children are on Lisbeth's side, as is the father: "Why should I punish Lisbeth because her mother can't stand her?" They

argue and the kids want the father to move out with them and let the mother try to get by alone but he can't do it.

"And we're up to our necks in debt. I don't know why, it's the wife's fault", Mr. R. says and describes how he brings home all of the money, perhaps 300 crowns a week, "But it doesn't last — and not until January when I'll be on my own"; and it sounds suspicious in my ears as he's an excellent hot-dog man. But I don't believe he's good at leading, at administrating a business. I suggest that we one way or another find Lisbeth another place to live, perhaps a rented room, but he reacts against it: "Why does she have to be thrown out again when it's not her fault, it's the wife's." Unfortunately, I had to end the conversation at this point as I had an appointment elsewhere, a half hour earlier, so I sent him to the social worker and suggested he have Lisbeth come in one day. I want also to talk to her before we make any moves in this case.

SH/IK

6/2–64

Mr. R. wants a divorce.

SH

18/2–64

Hedvig Schultz calls and at once says that Lisbeth must be removed now. The father cannot keep her at home and there are problems at her job. What she wants now is to be with her mother but the Child Ward Office won't allow that. The father's a wreck and on sick leave right now.

IH

8/6–64

The divorce has been finalized.

SH

6/8–65

Lisbeth placed in Herlev home for girls.

SH

26/9–66

And we've gotten a note from the tireless warden, Mrs. Schultz about Lisbeth. She's now living in Nyhavn, on occasion visits Halmtorvet (red-light district, ed.), where she's a hooker. And once in a while she visits Mrs. Schultz to take a bath. It may take a while but I am convinced that Lisbeth will at some time make it through. All of the chaos in her life can, optimistically, be interpreted as a sign that there's more staying power in her than imagined. One could also employ Vang Christensen's idea that she's reacting normally to abnormal circumstances.

SH/IH

23/1–70

Lisbeth is in great spirits. She's a big woman, a nice girl, well-dressed and groomed, chats in a lively and spontaneous way but she's not fresh, as one might have expected of her. She doesn't give a worn-down impression, but the fact is she's only 20 years old. We start, naturally, by talking about how the various family members are doing since she's been here last. The family's living in Venø Street with "Ellen" (the fathers new wife) and it's fine considering there's not much to get thrilled over as he's doing more or less O.K. with his hot-dog stand but his health's not too good.

The older sister Ida is married, although the marriage's far from perfect but that seems to be because Ida's going the way of her mother — "she's a bossy woman, keeps her foot on her husbands neck." Jørgen (the oldest brother) is a trained housepainter.

(He's the only one with training in anything.) In addition, he's a bouncer at Club 6. The youngest, Karsten is having problems, "he doesn't want to do anything", and he passes the time smoking hashish and that sort of thing. Lisbeth has no hope for him. Finally, Lisbeth herself and she's a thought-provoking person to meet. She speaks in a matter — of — fact and clearheaded way about her life. We run through the various institutions she's been at, Klemenshus in Ålborg was a place she didn't like. Himmelbjerggård, (under Jörgen Torpe), was a good place and she hasn't a bad word to say about it. The last place, Höjbjerggård, was in the city of Herlev; she didn't dislike it, they were more or less very kind there. But she repeatedly ran away from there, sometimes with others in order to "experience life here in the big city". And indeed she did as we have police records which I naturally didn't mention to her.

Then we talk frankly about the time she was a hooker at Halmtorvet. When I say "that time" it's because she insists it's a closed chapter now. That sort of life is something she's given up and she states directly that she never liked it. In the course of talking, she makes a few psychological observations. She didn't like the money that she earned that way and therefore got rid of it immediately. The other point is that if a "client" (she consistently uses this term) got too affectionate and friendly towards her, it became even harder to deal with him than if the relationship were purely of a business nature. However, she talks a lot about certain clients with kindness and points out that her clients are from all walks of life, including a Swedish Count. (It doesn't matter whether he's a Count or not).

She's also made some friends during this period, people she really cared about. She's rarely used contraceptives and thinks it is strange that she's never gotten pregnant. She expresses some anxiety about it as perhaps she can't get pregnant and that seems reasonable as she's had gonorrhea four times. This must be the price a prostitute pays for the life she lives.

For a while she has been working as a waitress on a ship but that was something she didn't care for as the atmosphere was too tough, among other things, she regrets the steward was so bossy towards them. She's tried a restaurant — she says she wants to be a waitress now — but the first one on Odins Street in Österbro was a spot she didn't care for and therefore came late and got sacked. When she leaves today she's going to try for a job as waitress somewhere else. We talk a lot about that kind of job and I admit that I encouraged her to stick to it as it's a training she can go through. She agrees and I feel in any case that she'll do her absolute best. Whether or not she plans to draw her career as prostitute to an end was something we didn't discuss and I didn't preach about it but I pointed out that the job would get tougher when she didn't have the stamina of youth and she agreed totally.

This talk lasted for at least a half hour and we ended with an agreement about her stopping by if she felt the need to talk about things. I tend to think she does. I had the thought that in her lovely green dress she'd be able to sit at any dinner table and function as a natural young girl of 20 and keep up a spontaneous conversation. Perhaps I exag-

gerate a bit but I feel not too much.

P.S. She's living now with her father. The mother's got a new husband, but not the one involved when the parents were divorced. She doesn't care much for her mother and as far as I know hasn't seen her in recent years.

SH/IH

1/6–71

Alas! It didn't work. Mrs. Hedvig Schultz called today that the situation is worse than it's ever been, as Lisbeth's a junkie and has a boyfriend who's a junkie too. She's got nowhere to live as well and that's what Hedvig Schultz wants us to help out with. Lisbeth refuses to have contact with the various narcotics aid centers as she doesn't want involvement with anyone who in any way works in an official capacity.

SH/IH

4/6–71

Of course Lisbeth doesn't show up for her appointment, nor does she cancel it. She shows up today without an appointment. What a change during the last one and a half years. On first sight she seems pale, thin, sad, dressed in a type of hippy outfit with a scarf on her head and an open denim jacket. She has no will to go on, it seems her last chance. She's a junkie. It turns out that she's been one for the last four or five years but at the time of her last visit one and a half years ago, she was off it. That is, she fooled me then. I don't recall if I'd asked if she was on drugs. In any case she said "no" or I'd have written it down. She doesn't hide the fact today that she's tried "everything". She's on morphine-base now, which as we know is one of the worst things one can get hooked on. She

states, however, that she's on withdrawal with her doctor, Vandal, and claims she gets four ml. methadone daily from him. She's moved around, even lived in a commune, "but one can only do that if you know them real good." At the moment she's living in a condemned apartment in the Nørrebro area of the inner city.

She gets by on welfare, 185 crowns a week, and her friend is a junkie too, also on welfare. She's unable to hold a job. Asked right out, she claims that she'd love to work in a kindergarten but admits she can't cope with the job right now, "cause I find I get exhausted just trying to clean the house and clean up at home." Even with the withdrawal, she admits that her friend and she take drugs at least a few times a week — "we just need it." Living with her father is out of the question, despite his excellent apartment, which I've visited, as she doesn't get along with her father's wife. Incidentally, the father no longer has the hog-dog stand, had back pains, a recurrent problem. He is now on welfare. As far as I recall, Mr. R. gets partial-handicap funds. The mother is totally out of the picture.

Lisbeth asks if she can get an apartment.

SH/IH

23/8–74

This morning Lisbeth called: I found it a voice from the grave as I was sure she'd passed on. Somebody who treats addicts told me that her liver was infected but apparently it's not. The voice on the phone is not under the influence of drugs, I can tell. She requests an appointment right away, today, Friday afternoon.

And then Lisbeth shows up, she has be-

come bigger and heavier, probably because she is drinking beer instead of taking drugs. She has, as she explains, recently been through withdrawal with the help of the Church's Salvation Army, but as she puts it herself (that girl can't be fooled) it hasn't helped much, because she doesn't have a job and can't get one. She doesn't have a place to live, "I can't get going, I feel empty — I am so depressed." Just some examples of her words during our talk.

After some time she comes to the point of her visit. She's left S.S.H. (a hospital, ed.); in her own words she was discharged. She was supposed to be on a "crash diet" but they caught her drinking beer (her habit) and the doctor in charge stated that if she drank then she couldn't be treated there so they'd just as well discharge her. But she now states that she liked it there in any case and it was rather a good place. I realize now that she's here to ask to be sent back there. We have Dr. Peter Ege in that ward and I request his involvement. He promises to contact the ward's doctors. He makes a telephone request and learns that they are willing to readmit her. It's late afternoon and the best thing to do is to drive her there now.

She sat in the back with Wivi and I could see her face in the mirror. It was poker-faced, even when she said that she wanted to go back to school (for an examination) and to start all over. Only once did she have a gleam in her eye and that was when she mentioned she liked to play the guitar, was good at it, but had none. We decided right there to give her one through Holm's foundation at Refsnæs (we still owe her something from the time she was hospitalized). I don't know if she actually

December 5th, 1974

Dear Dr. Heinild,

I've wanted to write to you for a long time and since everything is going well now, it's the best time to give a sign of life.

The best thing I've ever done in my life was when I forced myself to get in touch with you. I will never forget the reception and aid you gave me then, and not just now. Every time I think about you, it gives me such strength that with my own eyes I've been allowed to experience such a great person as yourself. The awareness of that will always help me in good and bad times. I've started school here and they'll help me after summer vacation when I start at the high school, which I should be able to do within a year. The feeling of learning gives me great satisfaction, a feeling I never thought I'd have. You can see how lucky I am as everything is easier when you're interested in what you are doing. For a long time I've had a dream about getting help to learn something but I didn't dare do anything but dream and now I'm in the middle of a great reality, a reality which I won't allow to be destroyed. I'm so happy here, I know it's only for a while and I really need this time. Dear Dr. Heinild. My guitar is the most beautiful thing I own. We are the very best of friends, we play together, we are serious together, we don't fight but we talk and we cry together. We want to be good to each other and we've already done a lot for this. Imagine that I am being given the chance to experience this. I am certain that my direction in the future has this melody: After high school, I'll probably be sick of school but I'll go on to the advanced courses. I'd like to try something which gives me the chance to help "prisoners within the walls" as they really need togetherness with others too. I know that I have a long way to go still but I take it one step at a time and I have to stick it out with patience (at last I feel how strong one gets from living).

I never dreamed I'd like dentists—Ha ha!—but it's great to get it over with, I haven't been near them in years and soon I'll look really good once more.

I want to end with this token of thanks to you:

She was alone
for years and years
Sure there were others
many, many others
She didn't find anyone
She walked and walked
many, many miles
led by luck
She saw someone
Everything brightened up
Yes, she's here
She wants to live
for many, many years.

Dear Dr. Heinild, thanks a million,

from Lisbeth R

Please send my love to Wivi.

Den. 5/12-74

Kære Heinild

Jeg har længe ville sende Dem en hilsen og da alt går godt nu, syntes jeg det er det bedste tidspunkt at lade høre fra mig på.

Det bedste jeg har gjort i denne tilværelse var da jeg tog mod til mig og kontaktede Dem. Glemme kan jeg aldrig den modtagelse og hjælp De gav mig, ikke blot i nuet, når jeg hver gang tænker på Dem, giver det mig en så stor styrke at jeg med mine egne øjen, har fået lov at opleve et så stort menneske som Dem. den beredsthed vil altid stå mig nær – mest i både med og mod-gang.

Jeg er begyndt at gå i skole hernede fra, og de vil støtte mig når jeg efter sommerferien starter på et realkursus, som jeg så skulle kunne klare på et år. Den oplevelse af at lære noget giver mig så stor en tilfredsstillelse

believed us.

This is the last chapter until now on Beth. I won't stop hoping that despite all she's been through that basic drive will bring her above water. Let's see: there's probably more to come.

SH/IH

1/8–75

I call Lisbeth. She's at the in-patient psychiatric ward. Her voice is dull and slow. Her first question is "Any news on the guitar?" I quickly answer that we'll forget about that guitar and buy a new one and I stress that what's important is that she still has the courage to go on. "Whatever happens, I'm going to start school in September." "It's like that time with the cat — that's how I feel now."

Because her brother stole her beloved guitar and messed up a girlfriend's apartment, Lisbeth reported him to the police and immediately regretted it. At a point when she was probably very drunk and felt guilty, she took a large quantity of some pills which some "smart" doctor had prescribed for her.

She's made it once more. She'll call when she is discharged and I'll check how in heaven's name we can get funds for a guitar and we'll have to get her a cat and an apartment. God knows how!

Wivi

23/10–75

Lisbeth kept her appointment today. She's in great shape, lively and talkative. She says right off that she's gotten an apartment: Bangerts Street 8, in the inner city slums.

Her night school classes from five PM to ten PM are going well. As mentioned earlier it's a technical preliminary class and can lead to what was a high school certificate, today

known as tenth grade. She lives off state funds, 1,200 crowns a month, which she gets half of on Mondays and the other half on Fridays. She's short of funds and didn't have enough today for cigarettes.

SH/IH

12/10–77

Lisbeth is going downhill again and I recall she's tried withdrawal before. She calls me last night, very late, from the Central Train Station, and is clearly in the pits. She wants methadone. She's got a cold walking the streets and needs about 900 crowns a day for her heroin. I tell her that she has to make it until tomorrow when I'm on the ward. Then it will be for real: Once more withdrawal with Peter, who knows best.

SH/IH

20/10–77

Lisbeth wants a long-term withdrawal on methadone upkeep. I tell her it's out of our jurisdiction and suggest she gets in touch with the Church's Salvation Army.

PE

7/3–78

She didn't want that, contacted me once more. I didn't know what to do — nobody wanted to help her. Right now, her setup is such, as mentioned earlier, that she has to walk the streets to make the 1,000 crowns she needs each day. She wants to visit me at home and does a few times at Phisters Street in the evening, bringing cakes for coffee, a couple of apples and whatever. And I write a prescription a few times for methadone (5 mg. 30 pills), e.g. on 22/10. Then there are the times when I don't mark it down, probably because I believed I could get her into Dr. Freitag's methadone withdrawal program. He had

good results, as indicated in the newspapers. I called him a couple of times to pressure him but it was out of the question before mid-January. That's why I started withdrawal with her: 10 plus 10 pills 7/12 and 22/12 and 14/1/78 to start with. We cut back to 9 plus 9 and I made the prescriptions over the phone to the drugstore. I pressured Dr. Freitag and I made him promise to call us when Lisbeth started with him — but he never did. The last prescription was on 14/1 to 23/1, still 9 plus 9. I haven't heard a word since from either Lisbeth, the Doctor or the drugstore. But she promised to call when she's O.K. I'm sure she will, sooner or later.

SH/KP

These are excerpts from Beth's case record.

Svend Heinild, b. 1907. Md. Exam. 1932, M.D. 1942. Specialist, Int. Med., 1942 and Pediatrics 1947. Chief Physician at University Hospital, Rigshospitalet, Copenhagen, Denmark 1948–1977.

IS THIS A HUMAN BEING?

The Book of Beth, is the story of a life that is incomprehensibly painful, so incomprehensible that it is nearly impossible to understand the words on the printed page. When I read Beth's account of her life I am continuously reminded of a similar reading experience: Primo Levi's remarkable book "Is this a human being?"

Levi is a young Italian engineer of Jewish descent who is deported to a German concentration camp in the beginning of 1944, and the book is an account of the year that he stays in the camp. That he survived at all was a miracle, a miracle of luck, a miracle of cunning and a miracle of vitality. But above all it was due to the fact that he only spent a year in the camp.

Levi's book, in exactly the same way as Beth's story, is on the surface a text that gives the reader a glimpse of the incomprehensible, the hell that is the concentration camp, the daily fight to survive. But beneath the surface of his text Levi poses profound existential questions about the utmost limits of human existence; the things people subject other people to; the possibility of retaining under the most inhuman conditions an almost secret place of humanity that inhumanity does not reach.

Consequently: the questions that Beth's story raise are: "Is this a human being?" and "Is this what we can do to a human being?"

The latter question is socially intolerable and of course absolutely inadmissible in the social and political rhetoric. It is my opinion that we in our Scandinavian welfare states — and in Sweden much more so than in Denmark — make a tremendous but collectively unconscious effort to interpret the reality that Beth describes in a way that exempts society and her "fellow-creatures" — in Beth's case the quotation marks around fellow-creature are certainly justified — from any part in Beth's unlucky fate. Consequently Beth's text is also a threat to the falsity of society, the supposed benevolence of society towards Beth. She paints the picture of a life where human beings are exploited to the limit.

The scene that moves me most of all is Beth's description of the outing together with her mother and "her new boy-friend".

"I've always fought for a place to be part of. Just like the time Mother and her new boyfriend drove me to Halmtorvet. Right after my parents' divorce. We were out for a drive and sat in the car, staring at all the hookers. I was so overjoyed that she suddenly cared about me. I jumped out and whipped up a John and his money so there were rounds of beer for us all. I wanted to: I was so goddamn happy and relished treating them. But it didn't last long. She was so sweet to me 'cause there was money floating around."

The account is so diabolical because it descibes a process which is idyllic on the surface; a family excursion; the mother with her new man and her daughter; the girl's happiness at being allowed to belong... for a Swedish reader the scene is replete with positive associations, party music, red and white flags, Danish beer and joviality.

But in the midst of all this: tragedy, exploitation. The daughter procures money "voluntarily", in order to be able to buy beer. "I was so goddamn happy and relished treating them." But nobody accepts her. Beth does not write the words, the all too transparent words, and it is this that makes her text "literary", a literary understatement. All the time it is a question of the child's love, the child's desperate love of her mother and her desperate wish to have that love reciprocated. The whole of Beth's story, on the surface a savage portrayal of her mother, is beneath the level of the text a declaration of love to that callous, emotionally frozen mother.

I want to return to my indictment against "society" and against the social explanation of Beth's life, that explanation which exempts us others from complicity and blame.

Society, especially the social care oriented society of Sweden and the Swedish political society, cherishes the theory that it is the drug itself that has wrecked Beth's life. She pros-

titutes and demeans herself because she is a drug addict. She must get hold of money for drugs; now that she uses heroin her daily need of 1000 Danish crowns equals ten or so acts of sexual intercourse.

This is a perfect explanation because it is impersonal. Beth's life becomes an affair between herself and the chemical substance. The duty of society to help Beth becomes instead a hunt for dealers and drug-addicts and the making of legislation that will scare drug-addicts away from drugs. In Sweden we have recently made the use of drugs a criminal act, and there is a strong political lobby for the imprisonment of drug-addicts — the crime that he/she has committed is just that, using drugs.

Beth's text can be interpreted in that fashion. As if her life were a hellish wandering from one torment to the other in order to get hold of the drug which for a short moment makes her free. In general the drug-addict has the same explanation himself — the drug is something *alien to self*, something which really doesn't have anything to do with my life but which nonetheless destroys my life. The drug-abusers fantastic dream takes one of two forms; either the fantastic "kick" which leads to a paradisiacal release from life itself, to a state of bliss which never ends or liberated life itself, full of love, of undemanding love.

To regard the drug as an evil impulse that has nothing to do with the person himself thus gives society the possibility of "combating drugs" and it also gives the drug-abusers life a sort of legitimacy: "it's not really me living my life, it is me the drug-addict and that's not me".

In order to be able to survive an extremely difficult crisis in life a person may split himself into "a me that is me" and "a me that is *not* me". I believe that it is the possibility of attaining this alienation of self, this division, that is the drug's real meaning for the "drug dependant" person. Another way of putting it is that it is the inner demand for the attainment of the division of self that is the real drug need. And the impulse? To avoid the terrible suffering that plagues the undivided self, the suffering and the betrayal.

In Beth's life the suffering that her mother causes her. There are awful scenes that Beth relates, I nearly can't bear to think of them. Her mother punishing her for bed-wetting the day after the failed attempt with the salted sandwich. "At midnight when she got me up again, I'd made in bed. That drove her nuts. A couple of hours later I'd done it again. Then she shoved me out into the toilet and then into the kitchen, where I was left on the table with my legs dangling down. She was totally hysterical and she made cuts on both sides of my knees. I burst into tears but was forced to keep quiet. Things would get even worse if I'd cried."

Is this true? Of course it's true!

But it is not only her mother's malice. It is also her father's betrayal and evasiveness. This betrayal is perhaps just as destructive as her mother's malice. The emotionally empty fahter figure provides the building bricks for a mental (inner) gestalt which leads Beth to create positive images of men. Images which are absolutely unrealistic and unattainable.

On what grounds can we dismiss the explanation that it is drugs that are the real evil in

Beth's life? A counter-question: how would Beth's life have turned out without drugs? There is suffering *before* drug dependency and *after* drug dependency and it is one of the greatest merits of her text that this theme is so well-developed and clear; this is also the reason that her words will be despised and misconstrued. She speaks about that which is forbidden, that the drug-abuser is an unfortunate person and that his misfortune is in fact a misfortune for society.

Of course this is the way it is. Her mother and father are wing-clipped and emotionally handicapped in their lives, just like Beth. They are poor, worn-out and emotionally deprived, brought up in the "fold of society".

We begin to approach the most difficult issue, the most difficult for me as well: why do we who work with society's child-care program fail to break the vicious circle, why does our treatment of Beth and her sister and brothers — remember the description of Basse in Beth's story! — often become something which reinforces suffering instead of abolishing or alleviating it?

Beth's wanderings from children's home to children's home, from institution to institution, are a crushing indictment of the institutionalized heartlessness of society's healers and semi-experts, meagerly equipped with a wretched professional language which in all its lengthy texts never mentions that which is so obvious: the child's need of love and attention. When the treatment is at its "best" Beth is at Himmelbjerggården, "It was the place that I always was running away from." And: "Deep inside I knew I could always come back and there'd be a good dinner and a bed for me. That's what the man in charge had

told the others — that I shouldn't be punished. That period is the only time I'd love to relive."

Obviously one wonders why Beth never was allowed to stay with a family, a family that quite early in her life could have supplanted the destructiveness of the biological family. But it is unlikely that a foster family would have put up with the enormously forceful way Beth tested other peoples feelings. Who wants to love a bed-wetting, aggressive child? I remember from the time I worked at a children's home our attempts to place our children in foster homes. We could estimate the wage a foster family should receive by summing up the child's symptoms, thieving, aggressivity, bed-wetting — everything had a price-tag. I write this in order to reaffirm the authenticity of Beth's story.

It is strange to read the parallel account to Beth's biography which bears the signature Svend Heinild. Svend Heinild has become an alter-ego for me, I recognize his thoughts as my own, they are full of insight and understanding and permeated with an awareness of his own powerlessness: "As long as we are unable to understand that it is the girl's family situation which should be treated and not her symptoms of pilfering, restlessness, smoking and sexual curiousity, which in themselves need treatment, then we haven't gotten very far in understanding in our child welfare. Thus we just continue on like the past generations with "organic" medical treatment diagnosing the symptoms but extremely rarely the whole picture."

I agree with Svend Heinild, but with my brief remarks I have tried to broaden the perspective. We must also take into account that which is outside and beyond the family, the social structure that causes inequality and which funds the social care system which in return, with its diagnoses and explanations, does society the service of declaring Beth and the circumstances of her life to be non-human.

A life is a venture, something that, subject to its circumstances, can be forged and shaped. Beth's gestaltning of her life is affected practically every second by her tremendous fear of the suffering which comes from the lovelessness which from the very beginning is the fundamental theme of all her meetings with other human beings.

But the strangest thing of all is that her life can also be seen as a repeated declaration of love, a declaration of love for her parents that were never able to give her any love. Her life is also a prayer and a spell — "see how I live, deliver me from evil!" But of course it is a spell that can never be heard, not by her parents, nor by anybody else.

This of course why Beth's story is a tragic one from beginning to end. She may stop using drugs — that's all very well — it means she may survive. But what words can she use to express her desperation in this stony-hearted world we have built for her?

Bengt Börjesson

Bengt Börjeson, b., 1932. From 1951—1981 has mainly worked at children's and juvenile homes. From the middle of the sixties also with patients with a history of drug abuse. Since 1981 professor in Social Work at Umeå University, Sweden.

September 1st, 1988

Beth stopped taking drugs and was completely free from
them for five months. Then she started again.
She's now taking 14 methadone pills / 5 mg a day and
200 stesolide pills / 5 mg a month.
When she didn't pay the rent, she was thrown out of her
room at the Vesty Boarding House.
She draws a "sick pension" and is on the waiting list
for an apartment.
Now she lives with a man in 16 square meters, two beds
and a sink.
She pays his rent and in addition is expected to satisfy
his sexual needs.
She's forced to pretend that she has abstinence symptoms,
in order to be left alone.
Beth is 39 years old.